YOUNG METEORS

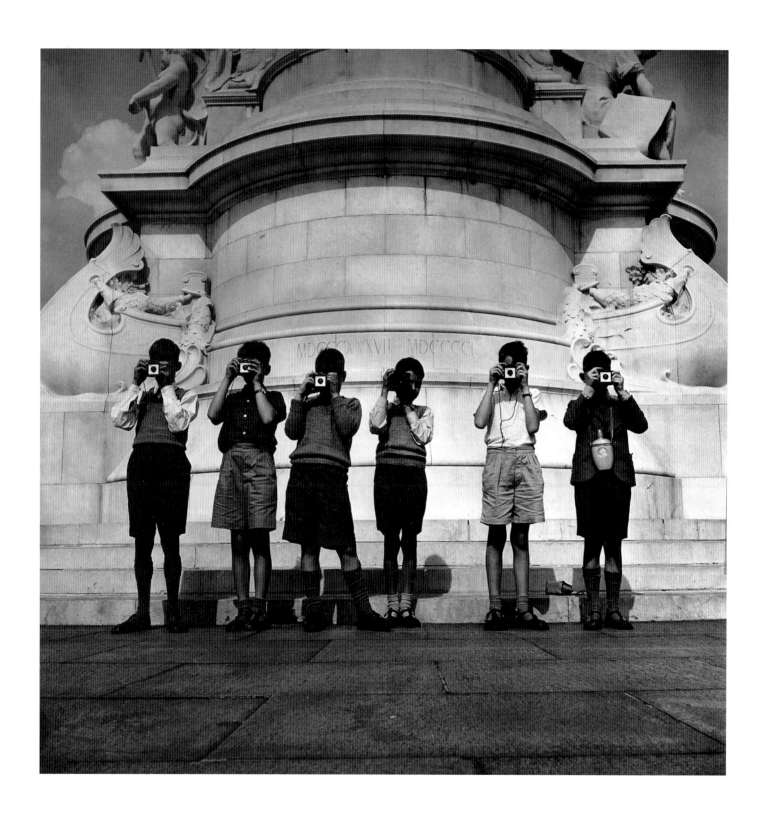

Don McCullin Boys' School Outing Photographing Buckingham Palace 1960.

YOUNG METEORS

BRITISH PHOTOJOURNALISM: 1957–1965

MARTIN HARRISON

JONATHAN CAPE
LONDON

IN ASSOCIATION WITH THE
NATIONAL MUSEUM OF PHOTOGRAPHY FILM & TELEVISION
BRADFORD

The front page of the *Independent* for 7 January 1998 proclaimed the rediscovery of the BBC's tapes of the Rolling Stones' radio sessions recorded between 1963 and 1965. The headline greeted the 'lost' tapes as 'Raw, Earthy, and Tender' – an apt description of the Young Meteors' photographs. Unfortunately, the retrieval of original visual material from the period is as serendipitous as that of its music; extensive archives have been lost or destroyed, and colour transparencies, in particular, were seldom retained by magazines and only occasionally by the photographers themselves.

The title 'Young Meteors', taken from Jonathan Aitken's 1967 survey of the financial enterprise of sixties youth, denotes a specific category of photographers. All are British and were in their twenties during the period between 1957 and 1965: that is, following the demise of *Picture Post* and up to the point when three 'colour supplements' were established and *Nova* magazine was launched. This study is almost exclusively concerned with photojournalism, and accompanies the first in a series of exhibitions organized by the National Museum of Photography, Film and Television that will explore the wider scope of photography in post-war Britain: the second will be concerned with consumer imagery and the inter-relationships between photography, television, advertising, and graphic design. This preliminary survey is limited to images made in Britain. Although this results in an unbalanced view of the range of many of the photographers' careers, especially of those who specialized in international issues, with the exception of the Algerian rebellion and the civil war in Cyprus, their coverage of foreign conflicts generally began after 1965.

While some of the Meteors are now considered doyens of photography, others have not maintained a high profile. Transitional figures of the stature of Nigel Henderson and Roger Mayne still await comprehensive retrospectives, and were it not for Sue Davies's pioneering exhibition, *British Photography 1955–65: The master craftsmen in print* (The Photographers' Gallery, London, 1983), the significant contributions of John Bulmer, Graham Finlayson, and many others would have been entirely unacknowledged.

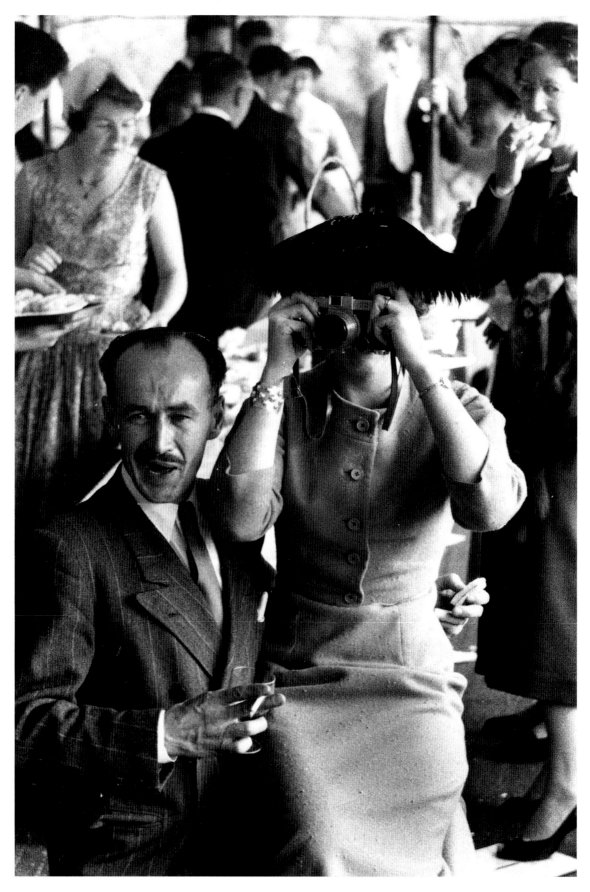

Graham Finlayson Wedding Guests, Southampton 1955.

To suggest that a homogeneous group of young photographers with a radical agenda emerged around 1957 would be, like most attempts to impose a convenient chronology on history, an over–simplification. But the Meteors were interconnected, often as colleagues seeking assignments within a specific sector of magazine culture. Although it was the style photographers who attracted most media attention in the sixties, there was a limited perception of a group identity for the photojournalists. Under the heading 'The casual cameramen', the Pendennis column of the *Observer*, 24 March 1963, reported on the formation of a new international movement, the European Magazine Photographers. British members John Bulmer, Philip Jones Griffiths and Don McCullin were described in terms usually reserved for fashion photographers: 'Studiously casual about their dress, Italian wool jackets, jeans and denim shirts ... and carrying their black 35mm cameras as unobtrusively as pistols, the EMP call themselves "photo journalists" rather than Press photographers, and talk, as painters talk, of "truth" and "integrity".'

In attempting to achieve images of 'integrity' the young photographers shared a commitment to combine the medium's two principal functions – the documentary and the pictorial. David Hurn suggests a third element, extra to the aesthetic or the conveying of information: 'If you look at the best photographs of, say, Philip Jones Griffiths or Don McCullin, they always go beyond the nominal subject, as if they are trying to present a summation, a symbol, of the event being depicted.' The Meteors also shared a curiosity about the history of photography (and perhaps a concern for their position within it), and developed an awareness of their distinguished forebears, including the pioneer documentarists such as Brady, Stone, Hine, and Riis, as well as Bill Brandt and Walker Evans. Though they identified with the humanist tradition they dissociated themselves from both their immediate predecessors at *Picture Post* and, as Pendennis suggested, the corps of press or news photographers: they were, in Bryn Campbell's words, 'the first generation with pretensions to be Cartier-Bressons or Eugene Smiths'. They aimed, however, to reconcile these artistic aspirations, and their political views, with earning a living from publishing their work.

Some of the Meteors' immediate European and American close contemporaries, for example Ed van der Elsken, Robert Frank, and William Klein, strictly separated their paid and their personal work.

(overleaf) **John Bulmer** England's Hard Centre *About Town* March 1961

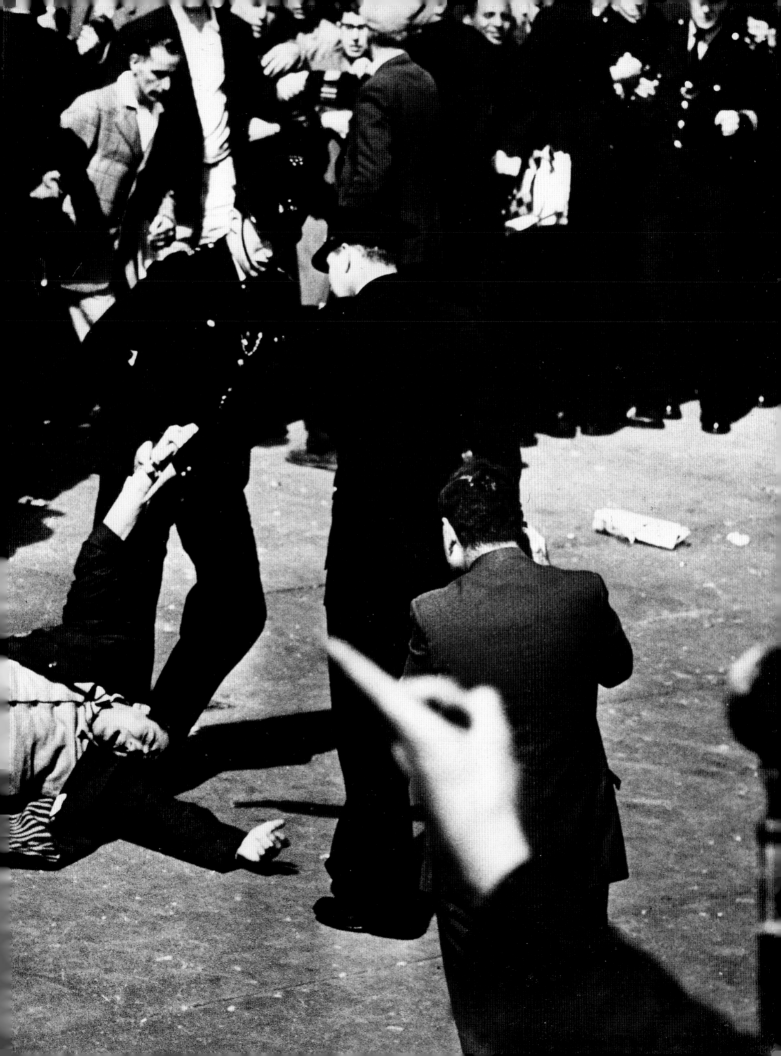

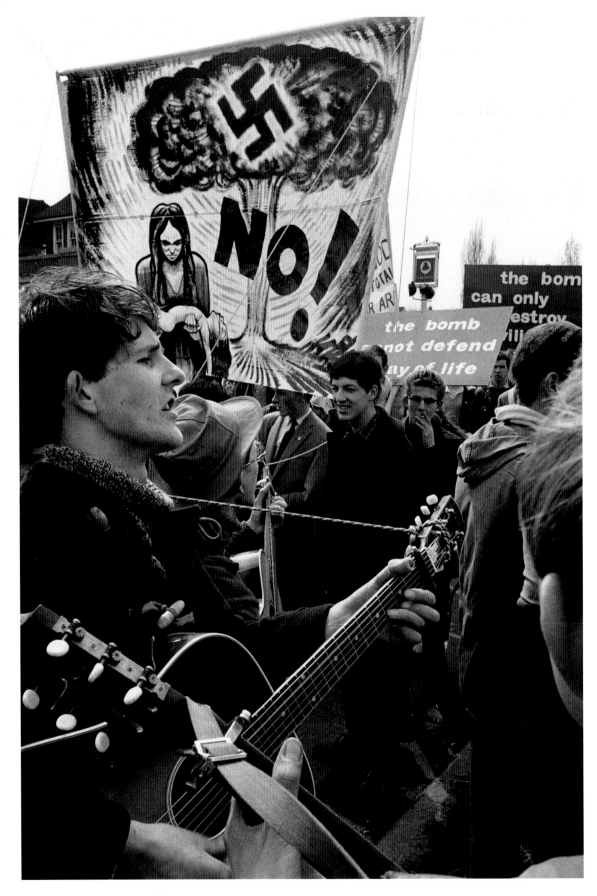

Philip Jones Griffiths Aldermaston March *Guardian* March 1960.

(preceding pages) **Don McCullin** National Socialist Movement Rally *Observer* July 1962.

Philip Jones Griffiths CND Rally, Trafalgar Square, London 1964.

All three had published their 'non-commercial' photographs in the 1950s, in book form as well as in photography magazines, but this was extremely unusual; the only realistic option for British photographers, other than retaining amateur status, was to seek employment in the mainstream media. Roger Mayne was an exception, for, while occasionally accepting commissions, he was able to remain, in the best sense, an amateur. He drew a sharp distinction between photojournalism and his personal work, whose subject matter, he insisted, was only 'superficially photojournalistic'. Recognizing that the dividing line was 'a narrow and subjective one', he believed that the difference lay in that 'the artistic photograph can sustain endless viewings' and was unequivocal that the end result of his endeavours was a print 'to be exhibited or to be contemplated on a wall'.

Two photography exhibitions whose international itineraries included Britain are almost universally cited by the Meteors as crucial influences. The first is 'The Family of Man', which, organized by Edward Steichen for the Museum of Modern Art, New York, came to the Royal Festival Hall in 1956; the second is the Henri Cartier-Bresson exhibition that was held at the RBA Galleries, London, before touring the provinces. The staging of the huge Cartier-Bresson exhibition was due principally to the efforts of Norman Hall. As editor of *Photography* magazine from 1952 to 1962, Hall was responsible for publishing the first editorial features on many of Britain's young photojournalists. In attempting to appeal to a broad audience, the content of *Photography* was 'soft' as well as 'hard', and neither in design nor in printing quality could it compete with magazines such as the Swiss periodical, *Camera*. However, its impact on British photography was considerable, as Philip Jones Griffiths confirms: 'Norman Hall was behind it all. Before, if you were serious you were put into the Royal Photographic Society pigeonhole; you had to take your work along to Princes Gate where all they wanted was saccharine landscapes, fluffy kittens or smiling beggar children, preferably with long titles. Suddenly, along came this man from Australia who showed us William Klein and Robert Doisneau; prior to that it was a wilderness.'

The Meteors absorbed the lessons of their foreign counterparts and were a conduit for the transmission of their influences into an almost moribund British photography scene. Even a cursory comparison of examples of photojournalism dating from, say, 1957 and from 1962, reveals the fundamental changes that had occurred in the intervening five years. The ideological base undoubtedly shifted, but what most differentiates the new photojournalism is its graphic structuring. Tauter and more vigorous, the photographs were aimed, when reproduced on the page, to demand the viewer's attention. Indeed, this was a prerequisite: Britain's first commercial television channel had been launched in 1955 and photography was

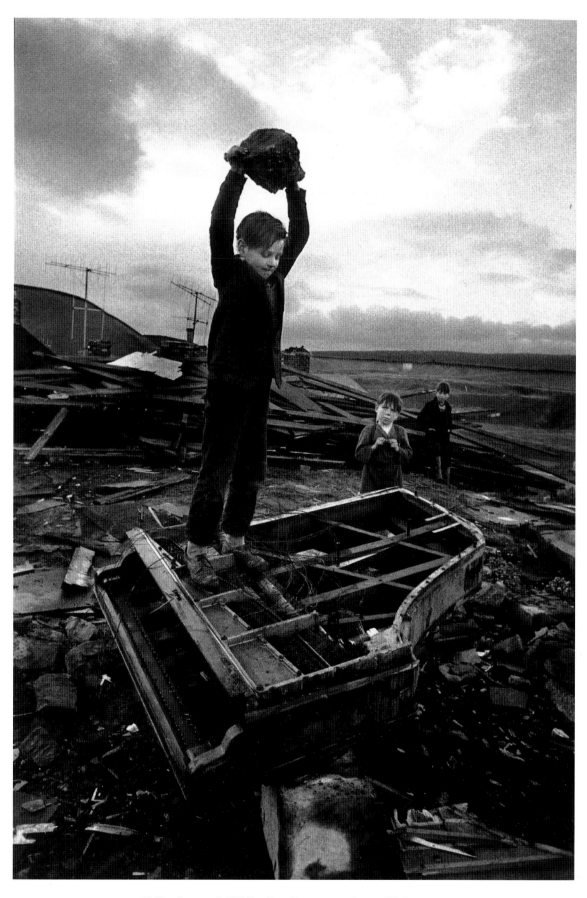

Philip Jones Griffiths Boy Destroying Piano, Wales 1961.

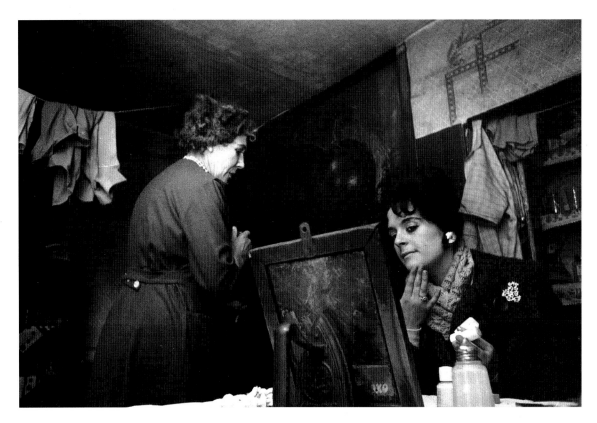

John Bulmer Tipton, Staffordshire
for 'England's Hard Centre: The Black Country' *About Town* March 1961 (unpublished).

competing for an audience that was increasingly visually sophisticated (and probably sated) as a result of the explosion of imagery that attended the first wave of the mass television age.

A key factor in this new graphic expression was the availability of 35mm cameras with easily interchangeable lenses. In 1960, for example, when John Bulmer came down from Cambridge, he was the first of sixty photographers attached to the *Daily Express* to use a 35mm camera: 'They resisted the smaller negative size and tried to get me to use a Rolleiflex, but the first one they gave me was stolen from my car, the second was run over by the Queen Mother's limo. At an event, with wide-angle and long lenses, and increasingly fast apertures, you could run rings around the press.' When Graham Finlayson began on the *Southern Daily Echo* in 1953, not only were 5x4 in cameras the standard equipment, the negatives were still glass plates. On moving, briefly, to the Manchester office of the *Daily Mail* in 1958 he changed to the more manageable 6x6 cm Rolleiflex. However, the resistance to smaller format cameras was maintained longer on newspapers than elsewhere and even the compromise of a medium-format camera earned the opprobrium of the picture editor, Charles Madden, whose only comment was, 'You need your fucking head seeing to.'

Philip Jones Griffiths 'Scottish Football Fans' Piccadilly Circus 15 April 1961.

The young photographers proved versatile in exploiting developments in technology. The alternate broadening and foreshortening of space brought a fresh dynamic to the printed page and it was this, more than specifics of content, that above all characterized the photojournalism of the 1960s. These devices were eventually over-exploited to the point of cliché: the anamorphic cinemascope view of a tightly cropped foreground figure against a deep, wide environment and the blurry, telephoto travelogue scene became ubiquitous in the colour supplements. Nevertheless, between the tension and drama of the wide-angle close-up and the lyrical dreaminess of the compacted telephoto view lie the visual framings that have become universally identified as metaphors for the spaces of the sixties: as Wim Wenders suggested in 1969 (regarding movies of America), 'Films ... should be composed entirely of long and wide shots, as music ... already is.'

The Meteors should not, however, be considered major technical innovators. For example, although the use of flexible, lightweight 35mm cameras was a crucial factor in the new photojournalism, cameras such as the Leica and the Ermanox, that helped facilitate the origins of photojournalism in Germany in the 1920s, had been employed by photographers in Britain

since the 1930s (Humphrey Spender, Laszslo Moholy–Nagy) and by many *Picture Post* photographers, including Felix Man, Bert Hardy, Thurston Hopkins, and Kurt Hutton. An aversion to flash illumination, considered inimical to the veracity of the document, was common to most photojournalists, and the manufacture of increasingly fast film stock rendered the use of ambient lighting more practicable. Ilford Ltd had introduced HPS, their first 800 ASA black and white film, in 1954; Kodak's 1000 ASA emulsion, Royal-X Pan, was launched in 1958 and an article appeared in *Photography* (January 1960) in which John Cowan endorsed its ability to 'give properly exposed negatives in very poor light'. (Ilford's more widely used 400 ASA emulsion, HP3, was publicized in the photo–press in 1960 with a night scene by Bert Hardy; their advertisement reproduced Hardy's 1959 photograph for 'Strand' cigarettes, the first example of a 48–sheet poster made from a 35mm original. After *Picture Post* closed, Bert Hardy was retained to take photographs for other Hulton Press magazines. When Odhams took over the business in June 1959 Hardy began to supplement his salary with freelance advertising commissions.)

After 1960, 35mm single-lens reflexes began to supplant rangefinder cameras as the favoured equipment of many photojournalists. Long focal-length lenses became longer and wide-angles wider, and some soon added the motor-drive, ubiquitous symbol of the mythical 'sixties' photographer, as it would later be of the paparazzi. The advent of the SLR marked the large-scale introduction of Japanese equipment on to the photography market. During the Korean war, American photographers on furloughs visited Japan and returned with Nikon and Canon cameras that, although still fitted with rangefinders, had a reasonable range of interchangeable lenses. The example of leading professionals such as David Douglas Duncan and W. Eugene Smith helped to create a demand that gradually broke down the virtual monopoly previously enjoyed by German manufacturers, and reasonably priced SLR cameras followed shortly after.

Don McCullin's earliest published photographs were all made with the square–format Rolleicord camera he had bought while serving in the RAF. In 1960 he was introduced to his first 35mm camera, an Asahi Pentax, by Philip Jones Griffiths, after which the Rolleicord was 'rested tranquilly on the chest'. The 3x2 ratio of the 35mm frame was central to the impact of McCullin's imagery. His innate ability to exploit the inherent dynamics and filmic immediacy of the format enabled him to translate scenes of violence or disorder through a tight graphic structure, imposing a visual order, at least, on the brutality and sometimes inexplicable horrors he witnessed. For McCullin, the wide-angle lens was a device that thrust him into a more intense relationship with his subject matter: 'I don't want to hide behind someone,' he insisted. 'I want to confront what I am photographing.'

Don McCullin East of Aldgate *About Town* February 1961.

Nigel Henderson
Bethnal Green c.1950.

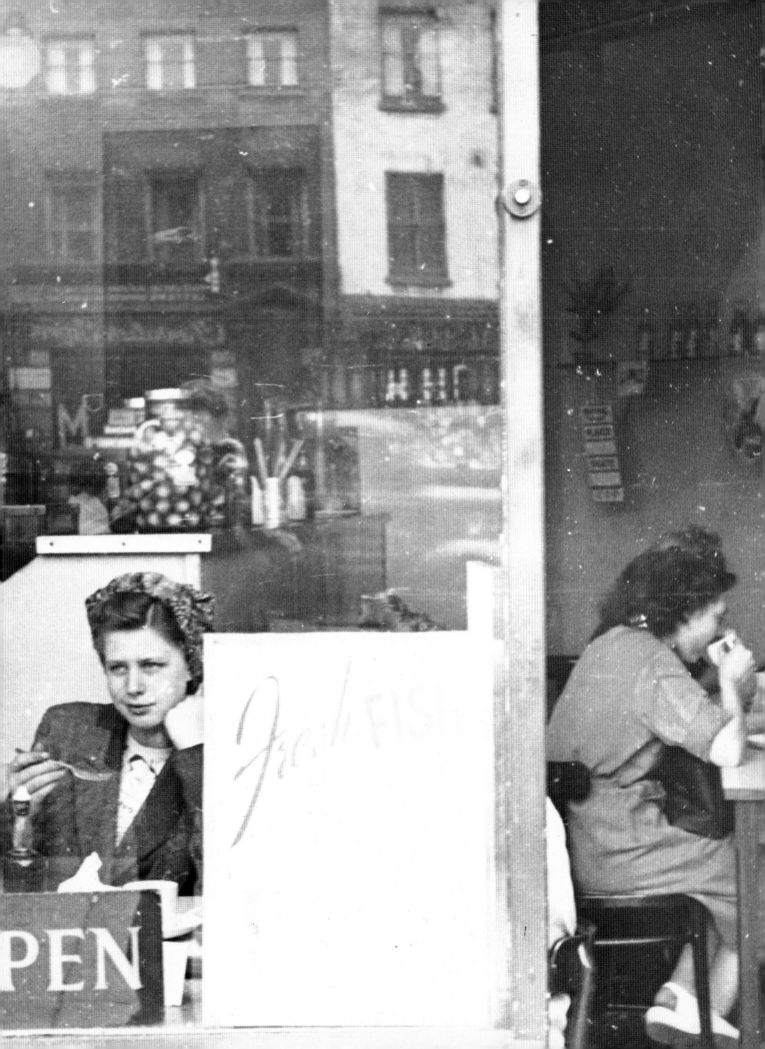

The Independent Group of the Institute of Contemporary Art was formed in 1952 around a nucleus that included the artists Richard Hamilton, William Turnbull, Eduardo Paolozzi, and Nigel Henderson, critics Reyner Banham and Toni del Renzio, and the architects Alison and Peter Smithson; among many influential figures who augmented the original core were John McHale, Theo Crosby, Magda Cordell and Lawrence Alloway. Despite internal dispute on the point, cumulatively the Independent Group accelerated the breakdown of hierarchical theories of art and enabled a multi-dimensional discourse that included, for the first time in Britain, the arts of the mass media. The ramifications of this process for mass-market periodicals – and hence for their photographic illustrations – were far-reaching.

The profession of photography was not high on the IG's agenda, but one of its members, Nigel Henderson, was a photographer. Henderson was responsible for two ostensibly distinct bodies of work. As an artist he worked principally in the medium of collage, although the collages frequently incorporated photographic elements, darkroom manipulations of 'found' forms and textures, and enlarged newsprint imagery. These images were publicly visible through his collaboration on IG exhibitions held between 1953 and 1956: retrospectively exhibited, but barely known outside the IG at the time, were the 'documentary' photographs he made from 1949 to 1953, a body of work that bridges Humphrey Spender's social realism of the 1930s and the later photojournalism of the Meteors.

Nigel Henderson grew up in direct and privileged acquaintance with many of the diverse surrealist, social realist, and anthropological impulses in British culture. He knew both Julian Trevelyan and Humphrey Jennings, and in 1938 worked with Marcel Duchamp on the installation of Duchamp's exhibition at Peggy Guggenheim's London Gallery, Guggenheim Jeune, where his mother, Wyn Henderson, was gallery manager. Humphrey Jennings's film *Spare Time* (1939) was partly located in Bolton, the 'Worktown' of Mass-Observation, recorded in the photographs of Humphrey Spender and others. According to Lindsay Anderson, Jennings's film 'on the use of leisure among industrial workers … aroused the wrath of more orthodox documentarians'. To a greater extent even than Spender's photographs it dwelt on the audible and visible signs of popular iconography – songs, comics, advertisements – a fusion of surrealism, documentarism, and English Neo-Romanticism, that would resurface in Henderson's photography ten years later.

Through his mother's friendship with Julian Bell, Nigel Henderson was introduced to a wide range of Bloomsbury Group activities. From 1933 he stayed frequently with Adrian and Karin Stephen in London, marrying their daughter, Judith, in 1943. At the Stephens' house he met producer Rupert Doone, who persuaded him to dance and perform with the Group Theatre, a left-wing anti-middle class co-operative that staged the works of Auden, Isherwood, MacNeice and Stephen Spender. The experience was, for Henderson, 'an attack on my acute self-consciousness'; his comment that 'I was trying, in this area, to throw off the mental-bodily strictures of my public school training' suggests a rejection of middle-class inhibitions that is echoed in post-war formulations of new attitudes towards leisure.

Following the war, in which he had served as a pilot in Coastal Command, Henderson suffered a severe nervous breakdown, but recovered sufficiently to take up a four-year serviceman's grant to study at the Slade School of Art. At the Slade, from 1945 to 1949, he was a desultory and intimidated student; never a proficient draughtsman, he failed to complete a single painting but began important friendships with Eduardo Paolozzi and, after Paolozzi moved to Paris in 1947, with Richard Hamilton. In 1945 Henderson had moved to a house in Chisenhale Road, Bethnal Green, where his wife, who had studied sociology and anthropology at Cambridge and at Bryn Mawr College, was running a course, 'Discover Your Neighbour', for the sociologist J. L. Petersen. She was helped in this by Tom Harrisson (co-founder with Charles Madge of Mass Observation), but although they both had 'occasional lunches' with Harrisson, her husband was not directly involved in the project.

At first in Bethnal Green Henderson 'just walked and walked and kept staring at everything', then 'it occurred to me after a little while that I might try carrying a camera with me'. He already had some awareness of photography, and had become familiar with books by Walker Evans and Atget while at the Slade, where he also borrowed a Leica, intending to document the School at that time. He began to photograph in the East End, sending some 'rather dim initial prints' to Paolozzi in Paris, but was uncomfortable with the Leica's diminutive viewfinder. Shortly after, Karin Stephen bought him a Rolleicord (6 x 6 cm), a 5x4 in plate camera and two enlargers, enabling Henderson to embark in 1949 upon what grew, over the next four years, into an extensive body of photographs recording the street life of his neighbourhood in Bethnal Green. In addition to the realism and vitality of his affectionate studies of 'the child culture in the life of the streets, roller-skating, fights, stump cricket and doodling on bikes' he was evidently fascinated by dense clusterings of graffiti and street signage. His flat-planed images of these inorganic traces of everyday human activity – like a less technically sophisticated urban vernacular version of Walker Evans – anticipated a 'pop' idiom that continued to resonate in British photography for at least two decades.

Nigel Henderson Bethnal Green c.1950.

As Chris Mullen has noted, Henderson's journalistic commissions (which he describes as 'another factor in damping down the aesthetic') have been largely ignored. It was never Henderson's intention to make a career of photography, although he admitted he 'got a little near' to it. His photographs were reproduced in the early 1950s in *Vogue, Cameo* (the first magazine owned by Jocelyn Stevens and art edited by Mark Boxer), the *Architectural Review*, and more extensively in the jazz-orientated musical weekly, *Melody Maker*. The final issue (January 1951) of Fleur Cowles's lavishly produced and short-lived American magazine *Flair* contains three of Henderson's portraits of actors, illustrating a feature on the Festival of Britain; further research will doubtless reveal other published sources. The *Melody Maker* assignments grew out of his friendship with Sam Kaner, an American artist and graphic designer who had joined Henderson's Creative Photography classes at the Central School of Arts and Crafts, London (1951-1954). Kaner had been a drummer in a US services jazz band and he and Henderson shared a love of jazz. Kaner 'knew the jazz scene well' and invited Henderson to join him in some work on English jazz musicians. They started with the recently formed Ronnie Scott Orchestra, who were, in Henderson's words, 'a brilliant bunch of musicians,

Nigel Henderson Bethnal Green c.1950.

musically very hip ... but visually square to the point of cuboid'. Working hard on one occasion to conceive for Ronnie Scott's band 'a visual presentation to match their musical inventions', Henderson was disconsolate at their dismissive reaction to his efforts, and appalled at the stereotyped alternatives the bandleader suggested: 'It's a shame,' he remarked later, 'that we fail to see equivalence readily across the barriers of specific media.'

According to Richard Lannoy, 'photography was a frequently discussed topic at the ICA'. Lannoy, a photographer and gallery assistant at the ICA, together with the Institute's assistant director, Dorothy Morland, were prime movers in the formation of the 'Young Group', a focus for the younger members' impatience with the Institute's hierarchy – directed especially towards Herbert Read – and the prototype of the Independent Group. When Lannoy departed in July 1952 to work for the UN's World Relief Agency in the Middle East, it brought about the disbandment of the Young Group. Before he left, the ICA had mounted exhibitions of Henri Cartier-Bresson ('a small but high-quality show of photographs from the forthcoming *Decisive Moment*') and of photographs from *Life* magazine. Lannoy was one of the young photographers

Nigel Henderson Watching the Boat Race, Hammersmith 1951.

published by Norman Hall in *Photography*, and worked for Hall for six months in 1956-57, helping especially with the 1957 Cartier-Bresson exhibition. Lannoy first returned from India in 1954 and was asked by Monica Pidgeon and Theo Crosby, editors of a new magazine, *Architectural Design*, to photograph Maxwell Fry's and Jane Drew's new buildings in West Africa, an assignment that Nigel Henderson (confirming his ambivalence towards commissioned photography) had turned down.

At night in the Henderson family bathroom, he and Eduardo Paolozzi experimented with photograms, and printed negatives made from unexposed film onto which they had 'drawn' directly. The exploration of the potential of 'found' raw materials connects several Independent Group members. Paolozzi had been working with appropriated advertising and popular comic imagery since 1947, John McHale's books of collaged newspaper and magazine texts and images were exhibited at the ICA in 1954, and from 1956 Richard Hamilton's paintings incorporated American magazine sources. Similarly, Alison and Peter Smithson, in their school at Hunstanton, Norfolk (1950-1954), specified pre-cast or standardized components that were assembled on site, with services and surfaces exposed – a response to social and physical, as

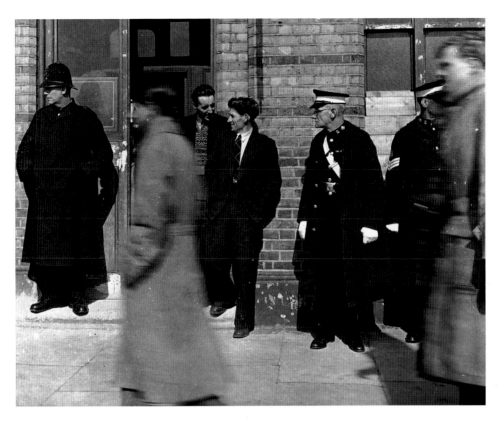

Nigel Henderson Watching the Boat Race, Hammersmith 1951.

well as economical realities; the affinity between the textures of shuttered concrete (New Brutalism) and Jean Dubuffet's augmented painting medium, including plaster, sand, and gravel (*Art Brut*) is not insignificant in this context, and points to the general IG interest in both Dubuffet and in Alberto Burri's organic burlap *Sacci*. In Henderson's case, though, this interest had specific sources in his study of biology – and discovery of microscopy – at Chelsea Polytechnic in 1935, and the isomorphic relationship he had observed (from aeroplanes) between markings on the terrain and botanical micro-sections. The IG exhibition *Parallel of Life and Art* (1953), a collaboration between Henderson, Paolozzi and the Smithsons, was presented not in the form of original art-works but as coarse-grained black and white photographic enlargements. These 'vituperative fragments', as Henderson termed them, were conceived not only as a kind of archaeological evidence of a former civilization, excavated in the aftermath of a nuclear holocaust, but also as indications of rich sources of imagery for the future. The material for the exhibition was drawn from 'life-nature-industry-building-the arts'; its mediation through photography, which was intended to challenge aesthetic hierarchies, substituting equally charged 'images' for the originals, laid down an important marker in the progress of the idea of the transcendence of 'the image'.

Photogram to suggest microscopic life. Made by contact printing 'junk' elements and projecting cellular texture from the enlarger probably by using loose-woven bandage as negative. Then the print was reversed.

Wood
Two paper negatives were combined in a single print. The left-hand one was derived from a charred log of wood; the right-hand one from a piece of weathered billboarding in a London street. One is a positive; the other a negative.

Nigel Henderson *Ark* 17 summer 1956.

IG ideology, however, whether New Brutalist or Proto-Pop, represented a minority view, even within the art world. The 'pop' sentiments of the Smithsons' 'But Today We Collect Ads' (*Ark*, 18, 1956), for example, were countered in the cultural mainstream in two books published in the following year: Evelyn Waugh's character Gilbert Pinfold, stoutly defending established values, 'abhorred plastics, Picasso, sunbathing and jazz', while Richard Hoggart, in *The Uses of Literacy*, was similarly uneasy with the threat posed by popular culture to the traditional consensus on taste. A further anxiety for the defenders of high culture was that when the Smithsons collected ads, Paolozzi collected comics, or Rayner Banham wrote on car styling, they were all referring to American products. Even before the rock 'n' roll invasion in 1956 there was strong resistance to 'Americanization', a residual reaction to the wartime influx of GIs and Britain's post-war dependence on US financial aid – a 'humiliating' reminder of the loss of Empire. The tone of a *Picture Post* photo-feature (May 17 1952) 'Should American Comics Be Banned ?' was typical; accompanied by a splendid photograph of a schoolboy in the throes of being depraved by the offending material, it exhorted readers to 'act now, before the moral values of our young people have become perverted by this degraded and degrading substitute for healthy enjoyment'.

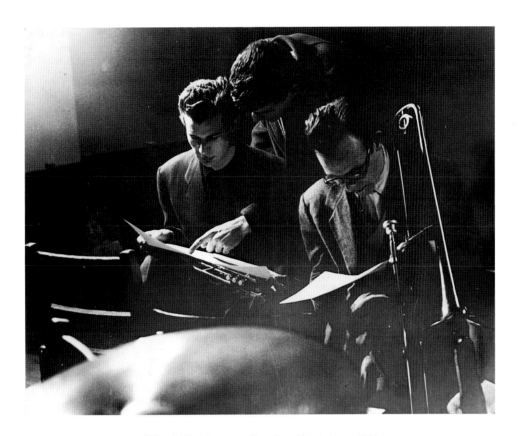

Nigel Henderson Session Musicians 1953
(Jimmie Deuchar, Harry South, Ken Wray, left to right)

The IG's interest in American design did not imply an uncritical acceptance of the capitalist system that produced it, neither was the enthusiasm unanimous. Toni del Renzio was not unreceptive, but neither was he prepared to jettison the totality of European culture, while Nigel Henderson, who as an artist was associated with the Constructivist wing of British abstraction, was a dissenter. To the extent that Henderson's Bethnal Green images might be considered Proto-Pop, their iconography was a relatively dowdy and eroded monochrome British version of the Technicolor American originals his colleagues avidly collected. Neither was the pro-Americana stance indiscriminate: in 'The Atavism of the Short-Distance Mini-Cyclist' (*Living Arts*, no. 3, 1964) Reyner Banham attempted to reclaim a more balanced perspective, insisting that most Pop was 'a wash of pulp which passes over you month by month ...'. The IG were not unanimous in regard to connections between technology, popular culture, and the idea of 'the image', nor, as Lawrence Alloway stated, was the interest in these areas manifested in a 'clear formulation of their function in relation to art'. But IG theories, which only peripherally affected the practice of photography itself, were a catalyst for profound changes that would affect the use of photographs in the mass media.

In *Without Rhetoric* (1976), Alison and Peter Smithson recalled the appeal for the IG of magazine advertisements 'whose technical virtuosity was almost magical so that one page must have involved almost as much effort as the building of a coffee-bar. This transient thing was making a bigger contribution to our visual climate than any of the fine arts ... ' According to Toni del Renzio, Lawrence Alloway was particularly conscious of the implications of his own career and that of Frank Cordell (who was married to Magda Cordell) in terms of reciprocating IG ideology back into the mass media. Frank ('The man behind Alma Cogan') Cordell was a musical arranger and conductor at EMI Records and worked with contemporary 'pop' session musicians on a regular basis; his article in *Ark*, 'Gold Pan Alley', was based on the talk he had originally given in the IG's series of public lectures at the ICA in 1955. Toni del Renzio's talk, 'Fashion and Fashion Magazines', was delivered as part of the same series, and it, too, was broadcast more widely; Hans Juda, who had chaired the meeting, published the lecture in his magazine *Ambassador* in 1956, and it was republished separately as *ICA Publication 2* in 1958.

Del Renzio's perceptive text on the female consumer of fashions carried an authority that was partly due to the insights he had gained working on magazines since 1951. From 1953 to 1957 (concurrent with his active participation in the IG) he was art editor of *Woman's Own*, a weekly with a circulation of over two million. As a teacher in the Printing Department at Camberwell School of Arts and Crafts, del Renzio had been an influential figure both before and after the war, and his ideas were also transmitted to the succeeding generation through lectures and journalism. In 1958 del Renzio joined *Harper's Bazaar*, where he found that the fashion editors had formed working relationships with photographers which precluded the art editor's intervention, and that the established photographers were resistant to innovation. He was, however, responsible for the first published photograph by Terence Donovan (*Harper's Bazaar*, December 1958), whose abilities he recognized when Donovan was still working as an assistant at the John French studios. Following a short spell at *Lilliput* in an unsuccessful attempt to rescue a title that he describes as 'unsaveable', del Renzio was involved with *Flair* magazine (the British version) from its inception in 1960; again this association was fairly brief, but it included commissioning some of the earliest independent assignments by David Bailey, in the brief period before Bailey's contract with *Vogue* prevented his working for the magazine's competitors. After this del Renzio moved to Paris, and from there to Milan where from 1963 to 1964 he was employed by *Novita*, in his last direct involvement with magazine publishing, overseeing its transformation into the ultimately highly influential Italian edition of *Vogue*.

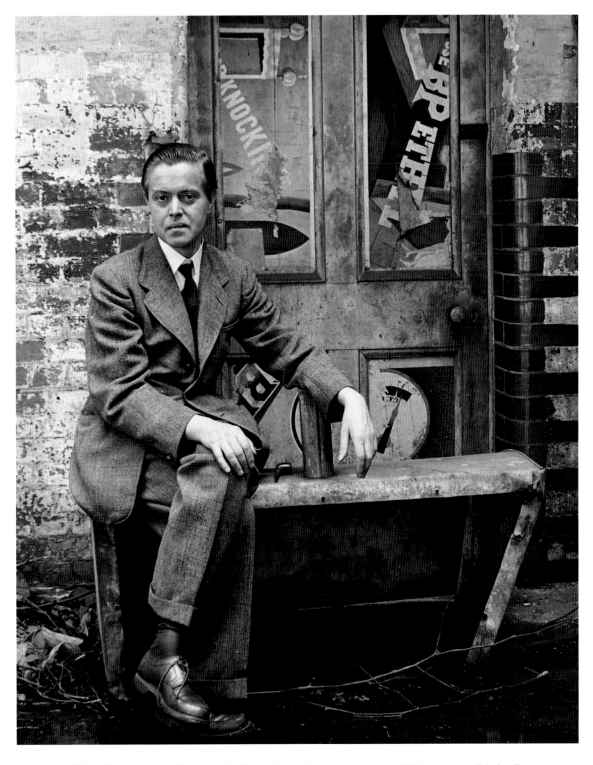

Nigel Henderson The poet W. R. Rodgers *Vogue* November 1952 (variant published).

In the preface to *The Street Photographs of Roger Mayne* (Victoria & Albert Museum, 1986), Mark Haworth-Booth described the widespread perception of photography in Britain after 1945 as 'a black hole ... until David Bailey, Don McCullin and others appear in the early sixties'. Cecil Beaton, Bill Brandt, and Bert Hardy were noted as exceptions and the exhibition itself marked the first serious recognition of Roger Mayne's seminal contribution in the 1950s. A thoughtful commentator on his chosen medium, Mayne's pioneering promotion of photography as an art left him somewhat isolated in the British photo-culture of the fifties.

On leaving Balliol College in 1951, with a degree in chemistry but a passion for photography, Mayne worked as the stills photographer on the production of a ballet film, *Between Two Worlds*, by the Oxford University Experimental Film Group. When his photographs were reproduced over four pages of *Picture Post* (15 December 1951) it was his first paid magazine feature. The encouraging start might have led to a career as a professional photojournalist; Mayne's disinclination to pursue this course places him in an unusual position. The ballet film was made in the gymnasium of Cheltenham College. Aware that Hugo Van Wadenoyen lived in Cheltenham, Mayne called at his house and struck up a friendship with the older man: 'Hugo became my mentor; my father had died two years before and I suppose he was a kind of father figure.' Van Wadenoyen was born in Holland in 1892 and was elected a Fellow of the Royal Photographic Society in 1918. Mayne was already familiar with the book *Wayside Snapshots* (1947), in which Van Wadenoyen demonstrated his break with pictorialism and commitment to a 'candid', informal approach that generally far exceeded the trite salon orthodoxies of that time. At the end of 1951 Mayne was called up for National Service, which he spent working in a hospital in Leeds. He had discovered Paul Strand's *Time in New England* while at Oxford; now he 'scoured Leeds Public Library' and – at first uncomprehendingly and then in admiration – pored over Walker Evans's *American Photographs*, as well as Cartier-Bresson's *Images à la Sauvette* and Eugene Smith's photographs for *Life*. Through Van Wadenoyen he became involved in the Combined Societies group exhibitions: 'Hugo was interesting because he was a go-ahead judge who still had one foot in the world of pictorialism. I particularly approved of his idea to augment the panels who judged competitions with people outside of photography clubs; this was how I met John Piper, who helped out quite a lot, and Lynn Chadwick.' But the first artist Mayne had encountered was Sam Kaner, who was responsible for the scenario, sets and costumes, for the Oxford ballet film. Having arranged to meet Kaner in London in 1953, he found

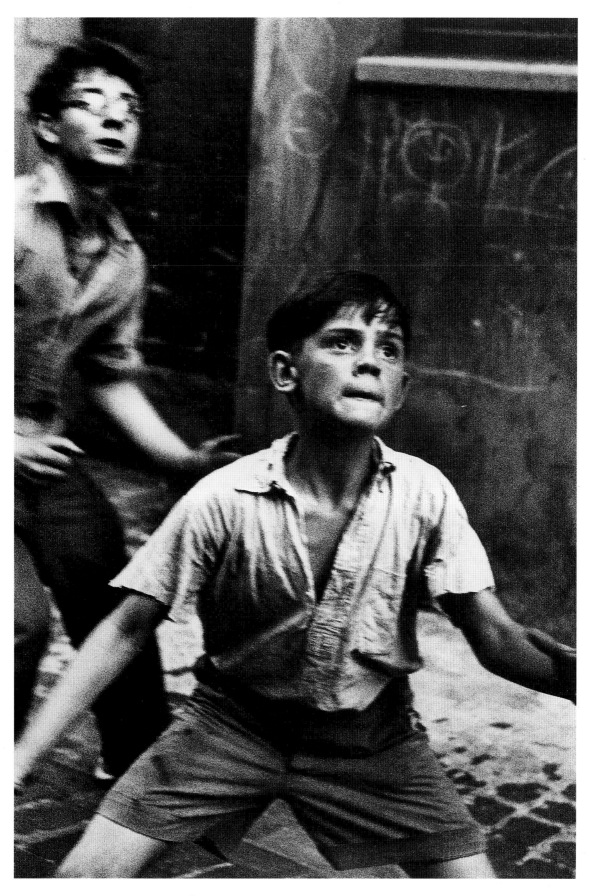

Roger Mayne Cricket, Addison Place, North Kensington, London 1957.

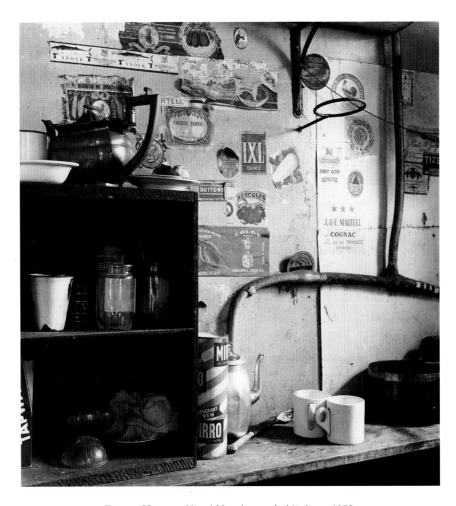

Roger Mayne Nigel Henderson's kitchen 1953.

that he was staying with Nigel Henderson and his family in Bethnal Green. He met Henderson for the first time on this occasion and photographed interiors of his house; he also made a photograph in Victoria Park, Hackney (including Henderson's children, Justin and Jo) that related to Henderson's photographs of street children and was prescient of his own future direction. In the tenuous continuum of British photojournalism the contact between Nigel Henderson and Roger Mayne in the 1950s was a bridge across generations.

Many of Mayne's earliest photographs in the 1950s were landscapes; the urban images among these sometimes included figures, but usually as incidental compositional elements. In 1955 he moved to Addison Avenue, London W.11, and began to document the life and people of the nearby district around Southam Street, North Kensington. The project evolved over three years into the extended 'Southam Street' series. Mayne's long-term project enabled him to build a relationship of mutual trust with the district's inhabitants, without which the series would have been impossible: 'The first obstacle I had to overcome was that the teenage boys, unaccustomed to seeing a photographer prowling their streets, assumed I was with the police.'

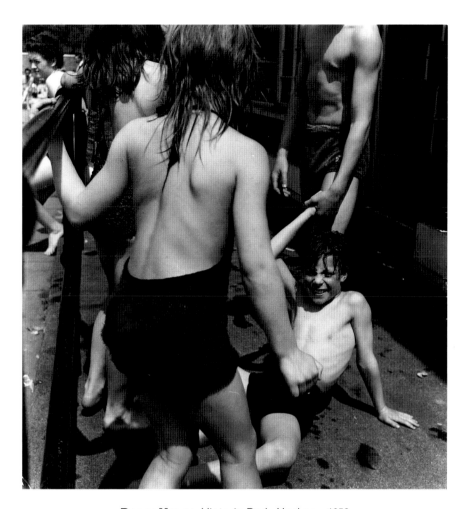

Roger Mayne Victoria Park, Hackney 1953.

Mayne had found his subject matter – people – and for the next decade they would be foregrounded in his photographs.

The phenomenon of people at play in city streets had been popular with photographers throughout the century, but in Mayne's photographs it appears to function as something more – a cypher for profounder changes in society, the release from post-war austerity, a defiance of authority and an awareness of the freely moving body as a form of uninhibited self-expression; as Theo Crosby observed of Mayne: 'He caught the poverty and the children's games all right, but he also caught the elusive whiff of the new abundance.' Mayne's sustained and concentrated documentation of flamboyant, rhapsodic gestures is a remarkable achievement. His ability to record this social upsurge so poignantly and adroitly was probably also due to his identification with, and admiration for, his subjects. His wife, Ann Jellicoe, has suggested that the series acted as an antidote to the formality and strict discipline of his own upbringing: 'Through photography he lived, justified himself, made contact with others and began to release the aggression generated in his childhood.'

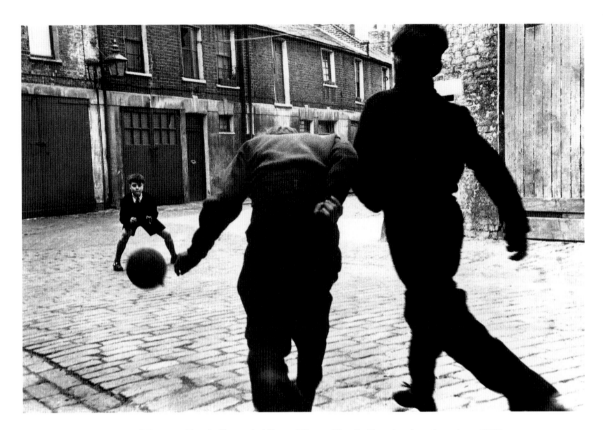

Roger Mayne Footballers, Addison Place, North Kensington, London 1956.

In the summer of 1956 the ICA staged Mayne's exhibition *Photographs from London*. On the Friday before it was due to close an unsigned review (which jointly noticed John Deakin's concurrent exhibition of photographs of Paris, held in the gallery of David Archer's bookshop in London) appeared in *The Times* under the heading 'The Photographer As Artist'. The anonymous author was the novelist Colin MacInnes, who praised Mayne for resisting 'The temptation to portray these urban primitives either picturesquely or else dramatically ... If one wants to see what a "Teddy Boy" really looks like – in all his drab and appalling splendour – there he is, captured by Mr Mayne's unerring, sympathetic, candid eye.'

MacInnes's encomium ensured that the exhibition was extended by one week, during which time it was picked up by the *Observer*, which reproduced four photographs on the cover; shortly after David Sylvester added his praise in the *Listener*. The exhibition boosted Mayne's reputation and increased the opportunities to get his work published. But he was not a career photojournalist and was seldom at ease working to a tight brief or trying to interpret someone else's idea. He struggled, for example, following storylines set by the tabloid *Sunday Graphic* that were remote from his own concerns; Mechtild Nawiasky, art editor of the *Observer*, admired

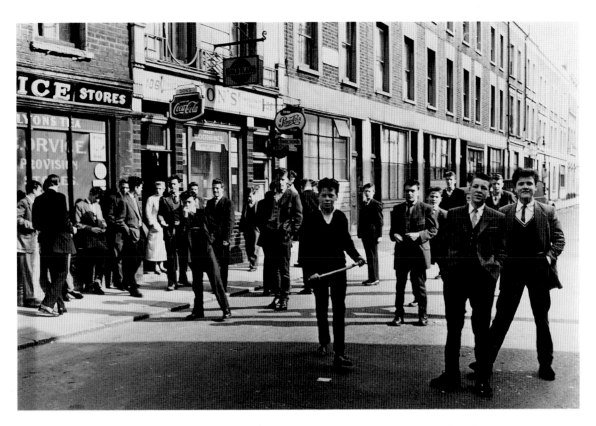

Roger Mayne Teddy Boy Group, Princedale Road, North Kensington, London 1956.

his work but felt unable to use him more extensively because of his apparent inability to fall in with the newspaper's established mode, explaining 'It has taken me five years to train Jane Bown in our house style ... ' Many of Mayne's commissions over the next three years, especially those for *The Times*, the *Sunday Times* and the *Observer*, drew on his reputation as 'photo-laureate of teenage London' and were often drawn from existing stock. As *Vogue* geared up to a 'new' social (and style) phenomenon, the magazine provided a more conducive assignment, to illustrate a feature on 'The Teenage Thing': 'They had originally suggested an essay on Teddy Boys, but it was explained to them that Teenagers were the latest thing. A friend, Alex Jacobs, found the people for me, mostly in Soho – I knew nothing about the "correct" fashions of the time.'

The principal character in Colin MacInnes's novel *Absolute Beginners* (1959) was a teenaged photographer who was based in the same North Kensington district of London as Roger Mayne's 'Southam Street' photographs, and given MacInnes's continuing admiration for his work it is not surprising that he chose Mayne to take the photograph for the dust-wrapper. Moreover, both the novel and Mayne's street photographs were concerned with contemporary

Roger Mayne 'The Teenage Thing' *Vogue* December 1959
(The teenager in this photograph is Clive Powell, shortly to be renamed Georgie Fame).

(upper and lower) **Roger Mayne** 'The Teenage Thing' *Vogue* December 1959.

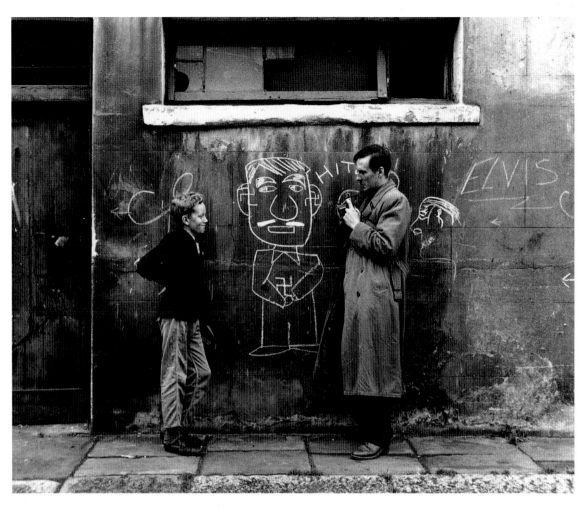

John Deakin Roger Mayne and friend, Addison Place, North Kensington, London 1957.

cultural issues such as social mobility, shifting, transient populations, and the role of play in the urban environment. MacInnes was responsible for setting up the picture (including selecting the street – 'It was off the north end of Ladbroke Grove and was not one with which I was familiar' comments Mayne), which is highly effective in conveying the edgy atmosphere of the novel. The result, however, is clearly a 'directed' photograph, implying a level of intervention that goes beyond the interaction with his subjects evident in some of Mayne's street photographs; at odds with the 'remarkably truthful portrait of street-life' which MacInnes had first welcomed in the *Observer*, it was not an idiom with which Mayne was comfortable.

In the same way that Nigel Henderson's involvement with the Independent Group connects with the New Brutalist architectural theories of Reyner Banham and Alison and Peter Smithson, Roger Mayne's photographs address issues concerning the built environment that were at the centre of architectural debate in the following decade. The language of the new architecture,

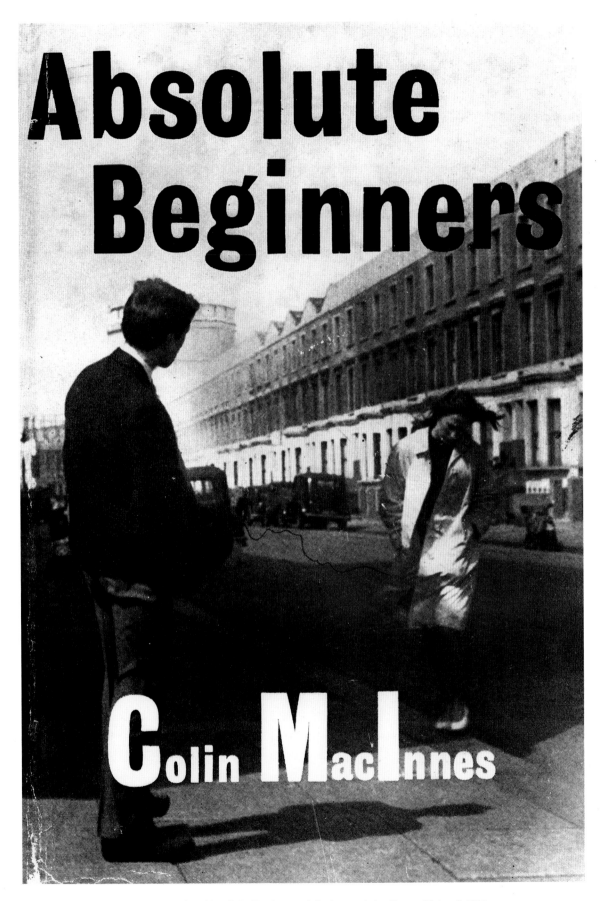

Dust jacket for *Absolute Beginners* (photograph by Roger Mayne) 1959.

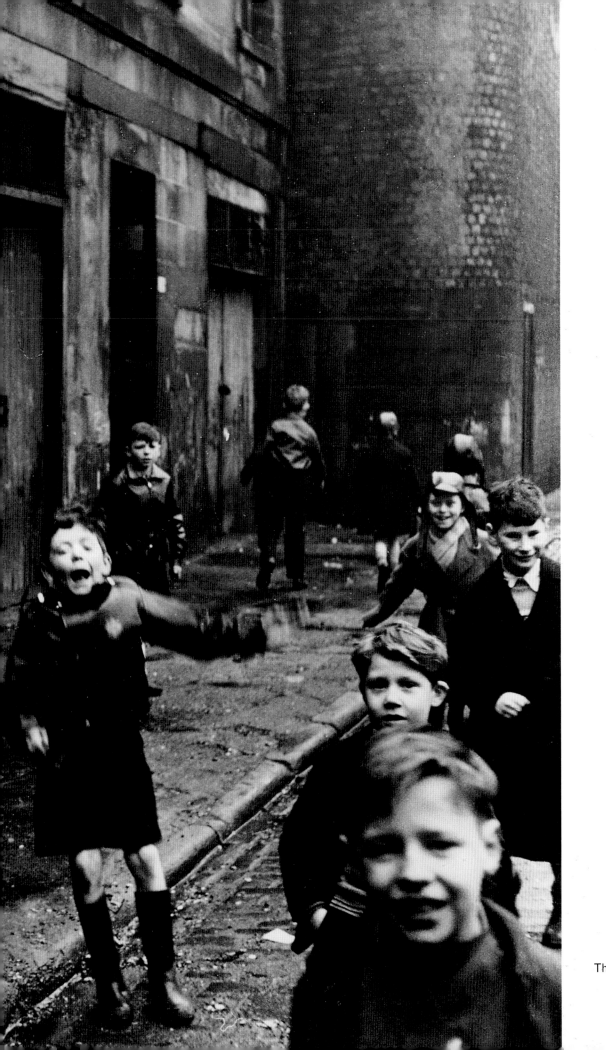

Roger Mayne
Group of Boys
The Gorbals, Glasgow 1958

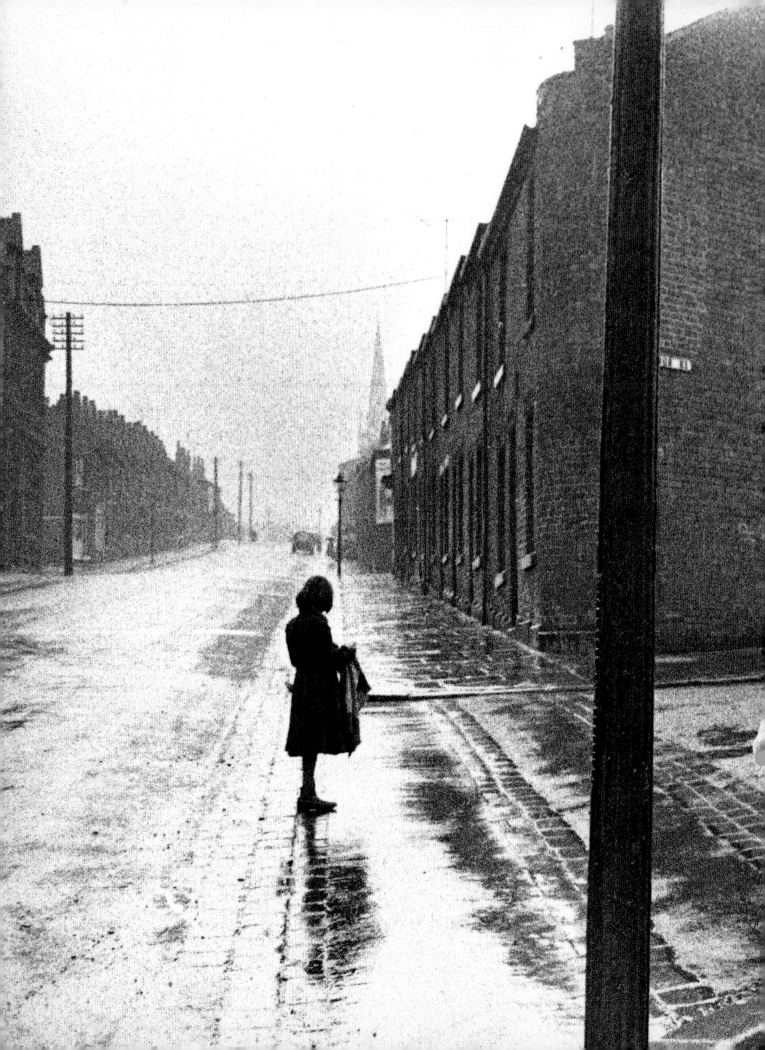

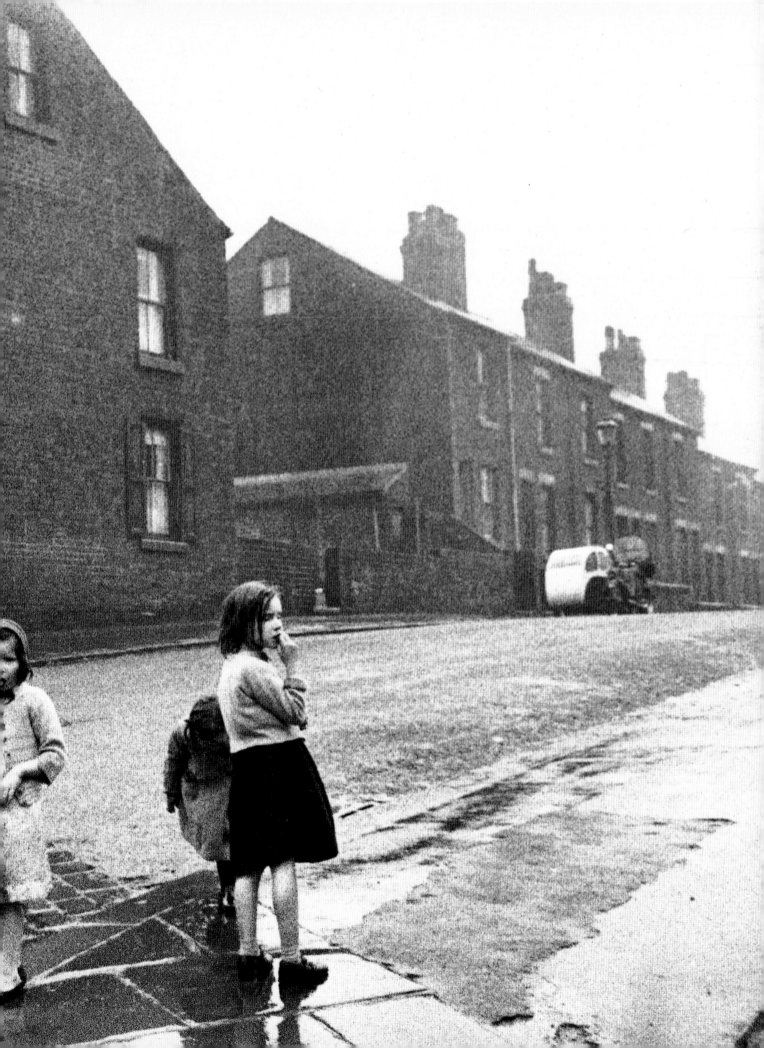

which emphasized openness, indeterminacy and impermanence, was based on notions of the city-in-flux and urban transience echoed in Mayne's imagery. Cedric Price's unexecuted 'Fun Palace' leisure project (begun in 1962) for Joan Littlewood was conceived as a 'space mobile' or 'giant toy' that would provide a 'laboratory of fun', a 'university of the streets'. Littlewood's interests, rooted in the Victorian tradition of popular theatre, devolved on public participation and improvisational performance; Price pointed out that the complex, 'which enables self-participatory education and entertainment' was only intended to work 'for a finite time'. An informal architecture that incorporated elements of planned obsolescence was conceived by the young founders of the Archigram group; Peter Cook's 'Plug-In City' (1963-64) envisaged high-tech forms that had a limited useful life; Ron Herron's and Brian Harvey's neo-futurist 'Walking City' (1963) was designed to have retractable legs and to glide on a cushion of air.

As an architect, theorist, editor and designer, the career of Theo Crosby spans both the Independent Group and the environmental and architectural movements that followed it. He was the main organizer of the IG's swan-song exhibition *This Is Tomorrow* at the Whitechapel Art Gallery in 1956, and technical editor of *Architectural Design* from 1953 to 1961. One of Crosby's last contributions to *Architectural Design* was to commission photographs from Roger Mayne to illustrate a 36-page feature on post-war development in Sheffield, in particular the new housing estates at Park Hill. In these high-rise dwellings architects Jack Lynn and Ivor Smith, who had been closely associated with Alison and Peter Smithson, adopted the Corbusian 'streets-in-the-air' concept that the Smithsons had proposed for the Golden Lane Housing Project, City of London, in 1952. Designed to retain the social structures of the slum areas it replaced, Park Hill was a well-meaning scheme which placed sociological principles above architectural aesthetics. The results failed to impress Roger Mayne, however, as his photographs testify: 'They were essentially the same as my street pictures – only against a much less romantic background. But this was the sort of brief I welcomed; I could take the pictures in my own way, and spent six days in Sheffield on the assignment.' Architectural photography as such falls outside the scope of this study, but Theo Crosby's enlightened patronage of Mayne for this assignment is an early example of the attempt to illustrate architecture as pre-eminently a site for social interaction, prefiguring the *Architectural Review* 'Manplan' issues of 1969 and 1970, photographed by Ian Berry, Patrick Ward, and Tony Ray-Jones among others.

From 1958 to 1961 Crosby was editor of a small-format communications arts magazine, *Uppercase*, and in 1961 devoted half of *Uppercase* 5 to Roger Mayne's Southam Street photographs. Included in Mayne's accompanying text was a plea for the 'beauty' and 'vitality' of

areas designated for slum clearance (the Southam Street neighbourhood was demolished shortly after): ' ... the planners are not sufficiently awake to the qualities of these streets which ultimately will have to go'. The synchronicity of photography with the idea of the city as a site for movement, energy, and a stimulus for social change, is omnipresent in another magazine edited by Theo Crosby, the ICA's *Living Arts* (2, 1963); Peter Cook's manifesto introduction to Archigram's 'Living City' exhibition at the ICA, in which 'The image of the city may well be the image of the people themselves' is virtually a definition of the correspondence between photography and the social environment it describes: '*Situation Change*, as spectator changes – the moving eye – sees, an environment and situation related to individual perception, mood, purpose, direction, and the place of the individual in the environment.'

In the same issue of *Living Arts*, a group of photographs by Robert Freeman addresses the theme of the urban environment, which he described as 'not a landscape ... but a shifting complex of visual experience ... a continuous fusion of things seen'. In 1959, while still reading literature at Cambridge, Freeman began to attend ICA meetings and lectures that explored the connections between painting, architecture, graphics, and film. For Freeman, Lawrence Alloway was a key figure, 'whose thinking consolidated these cross-currents into one subject – Understanding Media; everything seemed to be about the relation of man to machine, the new cities and creative extensions of technology, and I began to make fotomontages in the man-and-machine mode'. Even as the original Independent Group dispersed, some of their interests were perpetuated by a younger generation. The relationship between art and the mass media continued to dominate the programme at the ICA and figured prominently, for example, in the issues of *Ark* edited by Roger Coleman, and in Robert Freeman's *Cambridge Opinion* (17), which included articles by Alloway, Reyner Banham, and John McHale. Freeman's close associations, at this time, with the 'Situationist' painters Richard Smith and Robyn Denny, and with Richard Hamilton, further exemplify photography's dialogue with contemporary painting and the increasing interaction between the media.

On leaving Cambridge in 1960 Freeman turned to street photography and visited New York where he sought out Robert Frank, whom he cites as an influence. At an ICA party he met Peggy Guggenheim and discussed the essential difference between photography and painting. She encouraged him to concentrate on photography's ability to seize the ephemeral – traces, shadows, marks – and 'this was how I came to take "Brake Marks on a Zebra Crossing" and "Shadows of Man Against an Illuminated Map".' Freeman joined the ICA as an exhibitions organizer, directing a lecture series 'Image of Tomorrow – Urban X-Ray' and a programme on communications after Alloway had resigned in 1961. At the same time he launched a career that

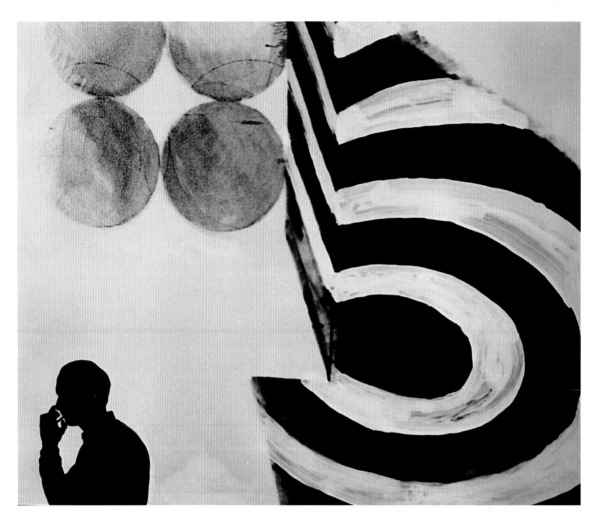

Robert Freeman Richard Smith – Silhouette with painting, 'Package' 1962.

is paradigmatic of the quintessential sixties photographer. Initially specializing in photographing jazz musicians, he was soon contributing a wide range of features, including fashion photographs, to *Queen*, *Town*, and the *Sunday Times Colour Magazine*. In 1963 he photographed the first Pirelli calendar and the first of his four notable Beatles LP covers. The filmic frame-sequence imagery he conceived for the record cover and film poster of *A Hard Day's Night* (1964) led to director Richard Lester asking Freeman to design the final credit sequence for the film; in Lester's next film *The Knack* (1965, adapted from Ann Jellicoe's play), he was responsible for the opening credits, again in a polyphoto mode. In an apparently ineluctable progression, Freeman directed TV commercials and, in 1966, became a film-maker himself, beginning with a feature film, *The Touchables*, in 1968.

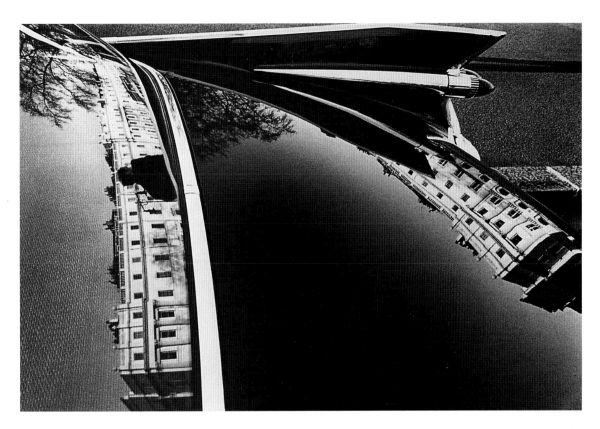

Robert Freeman Cadillac fin *Living Arts*, 3, 1964.

Robert Freeman Zebra Crossing With Brake Marks 1960.

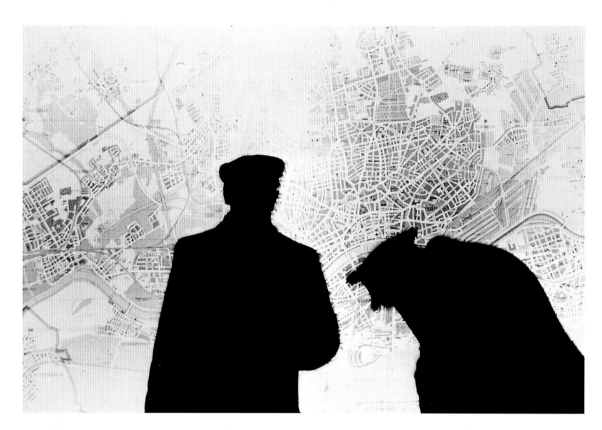

Robert Freeman Silhouette With Map 1961.

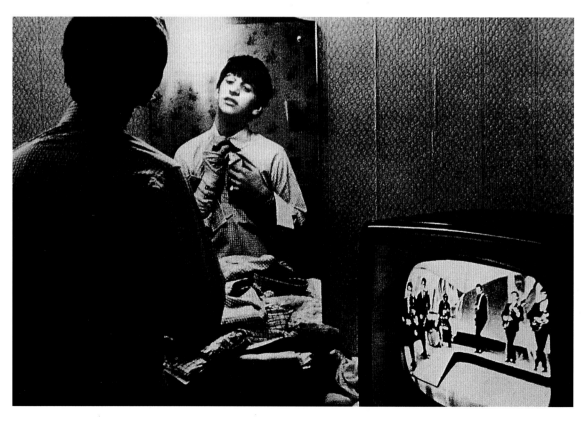

Robert Freeman Ringo In Mirror With TV 1963.

Robert Freeman Hard Day's Night, film poster 1964.

Robert Freeman The Knack, film titles (Rita Tushingham) 1965.

Demographically, not only were most of the Meteors born within the six years leading up to World War II, their first direct acquaintance with photography was generally while serving in the armed forces (conscription did not end until 1958) or at university. Since their contact with photography was primarily through magazines, from *Life* and *Picture Post* to *Vogue* and *Harper's Bazaar*, it was natural that they should gravitate towards publishing their work in the advertising or editorial pages of periodicals. An increasingly buoyant economy and the expansion of consumer markets was propitious for advertising photography, and some talented individuals made their careers in that direction. But there was a problem for those with ambitions in photojournalism. In 1957, *Picture Post*, formerly Britain's leading proponent of this kind of photography, was closed down, a victim of changing public aspirations and a rapidly expanding television audience. The demise, in rapid succession, of other picture magazines such as *Everybody's*, *John Bull*, and *Illustrated* eliminated further sources of employment. Inextricably associated with the war and the subsequent austerities, these magazines were in any case perceived as anomalous by the mid–1950s, their lingering paternalism anathema to a readership more interested in owning a car and a refrigerator. Circulations dwindled and so, consequently, did advertising revenue. In *Photography*, March 1960, Norman Hall declared that *Picture Post* had deserved to fail. He alluded to its illustrious past and admitted that it might have been great in the days of Tom Hopkinson, but said that latterly it had become a 'damn bad paper', using 'gimmicks ... stunts' and 'clogged with pictures of the Royal Family'.

However, as *Photography* had already noted (February 1960), photojournalism did not die with *Picture Post*. The alternatives, the newspapers and magazines where photojournalists were compelled to seek employment, become central to a study of this period. The Meteors did not, of course, operate in isolation. The effective presentation of their photographs depended on the sympathetic and sensitive collaboration of picture editors, writers, art directors and publishers: the convergence of graphic design and photography was central to the impact of images on the page. New periodicals were launched with increasing frequency from about 1960 and the migration of staff from one title to another renders the study of the contexts of published photographs in this period one of labyrinthine complexity.

In addition to certain newspapers whose layouts accommodated the occasionally generous use of photographs – notably the *Daily Express*, *Daily Mail*, the *Manchester Guardian*, and the *Observer* – fashion magazines such as *Queen*, *Town*, and *Vogue* provided valuable employment

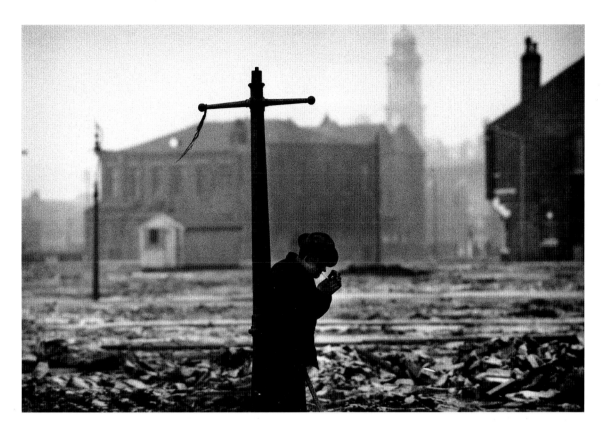

Graham Finlayson Clearance Area, Manchester 1960

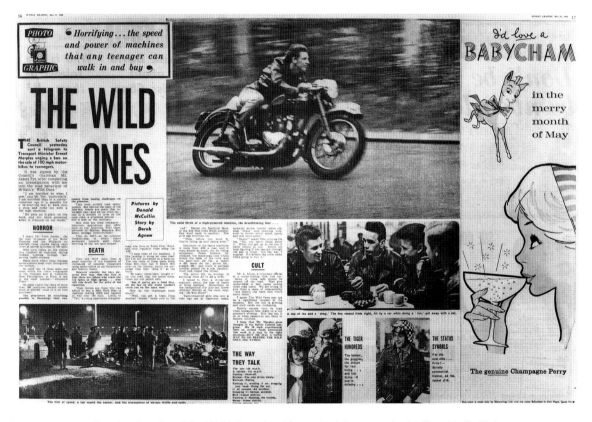

Sunday Graphic 'The Wild Ones' 15 May 1960 (photographs by Don McCullin).

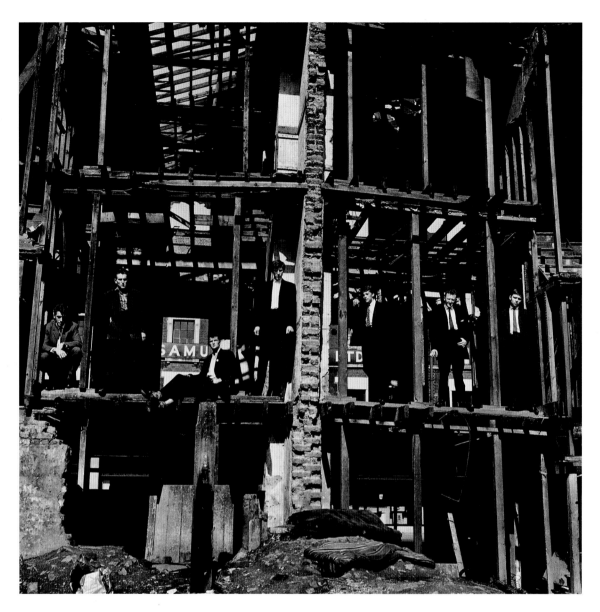

Don McCullin 'The Guv'nors' Finsbury Park, London 1958
Observer 15 February 1959.

Don McCullin's first published photograph, taken in 1958. The caption in the Observer *began:
'These photographs were taken by Donald McCullin, who has grown up with some of "The
Guv'nors", the reigning group of young men in the tenement heart of Finsbury Park, in North
London.' In 1958 a policeman had died from injuries sustained in a Finsbury Park gang fight, which
gave McCullin's photograph a topical edge. He was commissioned by picture editor Cliff
Hopkinson to take further photographs of the gang for the feature, and four of these were also
published.*

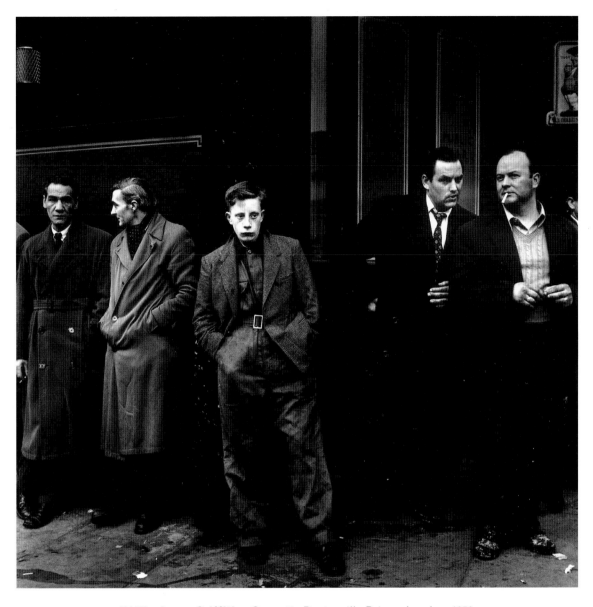

Philip Jones Griffiths Opposite Pentonville Prison, London 1959.

A twenty-five year old, Ronald Marwood, had been convicted of the Finsbury Park murder and sentenced to death. Philip Jones Griffiths's photograph shows a group of Marwood's friends standing morosely outside a pub opposite Pentonville Prison while Marwood was being hanged. A crowd of nearly a thousand had gathered to protest against the execution and Jones Griffiths covered the event for Pictorial Press. One hundred and forty-two murders were recorded in 1959 and six people received the death penalty.

for photojournalists, particularly during the five-year hiatus between the demise of *Picture Post* and the launch of the *Sunday Times Colour Section*. Today, the pages of a high-fashion glossy would be considered alien territory for the photojournalist, but this was not always the case in 1960. In this respect, the pioneer among the glossy magazines was *Queen*. Early in 1957 Jocelyn Stevens bought the title from his uncle, Sir Edward Hulton. Considering that less than six months later Hulton closed down *Picture Post*, the takeover assumes an extra significance as a potent symbol for the transition from the old to the new media. Previously, Stevens had been working at another Hulton Press magazine, *Lilliput*, where the art editor was Mark Boxer. Established in 1861, *Queen* was, by 1957, an ailing society and fashion periodical and Stevens's first step towards rejuvenating it was to hire Mark Boxer as his art editor. Stevens and Boxer, who had been at Cambridge together (Boxer was editor of *Granta* in 1952–53), immediately gave assignments to another former undergraduate, Tony Armstrong-Jones, 'to cover events like Henley or the Chelsea Flower Show in a less conventional way'.

The witty, irreverent photographs of Tony Armstrong-Jones (who became Lord Snowdon in 1960) not only enlivened *Queen* in the late 1950s but also the fashion pages of *Vogue*, and his action shots helped to revolutionize front-of-house theatre photography. His social clout doubtless helped in achieving these reforms, but his contribution in challenging entrenched attitudes was extremely beneficial for photography and should not be underestimated. The first books produced by any of the younger British photographers were two Armstrong-Jones volumes, *London* and *Malta* published in 1958. Designed by Mark Boxer, *London* particularly impressed contemporaries on account of the consistently grainy quality of the prints and the sustained down-to-earth informality of the whole. The antithesis of the dilute neo-romantic topographics that typified British 'travel' photography of the 1950s, *London* was both satirical and affectionate, a landmark in promulgating a crisper, 35mm vision of the social landscape.

The metamorphosis of *Queen*, meanwhile, proceeded quite cautiously, and unusually it was the art editor rather than the publisher who maintained a shrewd respect for the tastes of its ultra-conservative audience. Boxer remarked that Stevens had 'wanted to turn *Queen* into an up-market *Picture Post*', and believed that the extended coverage devoted in 1959 to Cartier-Bresson's photographs of Red China (eighty pages were published over four issues) was 'probably a surprise to many nannies and chatelaines in the shires'. Former *Picture Post* staffer John Chillingworth was responsible for some distinguished reportages, including un-posed and unusually natural society photographs that eschewed the disfiguring flash-illumination that had been the norm; John Hedgecoe, just out of Guildford School of Art and described by Boxer as 'my first discovery', set up a studio in the magazine's basement where he trained his 'almost

Tony Armstrong-Jones 'Christmas in Cable Street' (from *London*, 1958).

rural eye for the simplicity necessary for still-life photography'. Fashion and Society features continued to dominate the contents, but the fashion photographs, although by competent photographers like David Olins and Roy Round, broke little new ground, and it is hard to disagree with Boxer's assessment that 'Our fashion coverage never really picked up until Norman Parkinson joined us from Vogue in my last year at *Queen*.' Boxer's innovations were chiefly evident in the magazine's design and typography, but Reyner Banham, writing in the *New Statesman* (2 June 1961), still found *Queen* 'rather genteel' and indeed the reconfiguration of its layout was not fully accomplished until late in 1960.

Man About Town was a fairly staid gentleman's quarterly published by the Tailor and Cutter Ltd before it was taken over in 1960 by two Oxford graduates, Clive Labovitch and Michael Heseltine (Cornmarket Press), who immediately appointed Tom Wolsey as its art director. It has been claimed that the German magazine *Twen*, designed by Willy Fleckhaus and launched in 1959, influenced the re-designs of both *Queen* and *Man About Town*, but although Wolsey admired Fleckhaus's punchy layouts he was too devoted to great photography to want to rescue mediocre images with radical cropping. Photographers recognized that Wolsey fought for their images, even if they occasionally failed to appreciate his bold use of type over them. Wolsey's intention, though, was to minimize typography, not to subordinate it but in order to achieve a gestalt of word and image: in 1965 he explained that in his newly formed advertising agency, Stratton & Wolsey, 'I want to tailor the photography and copy to be inseparable, to strike the eye as one.' Consistent with his economical typographical style he fought against the magazine's title, which he saw as too cumbersome to permit a powerful graphic interpretation, but was only allowed to shorten it in stages, dropping the 'Man' and then the 'About' until in July 1962 it became simply *Town*.

In David Bailey's succinct phrase, 'the fifties were grey – the sixties were black and white'. Extreme contrast and the compression of mid-tone greys characterized the printing styles of most of the Meteors, signalling the medium's toughened stance in a 'high-definition' culture and a determination that their work should stand out in an increasingly image-saturated environment. Attempting to define New Brutalism in 1955, Reyner Banham recalled the '100 Brutalist images' of the Independent Group's exhibition *Parallel of Life and Art* and the shocked reaction to their 'deliberate flouting of the traditional concepts of photographic beauty': the Brutalist ethos was now being perpetuated in the hard-edge, stark contrast and grainy texture of commercial photography.

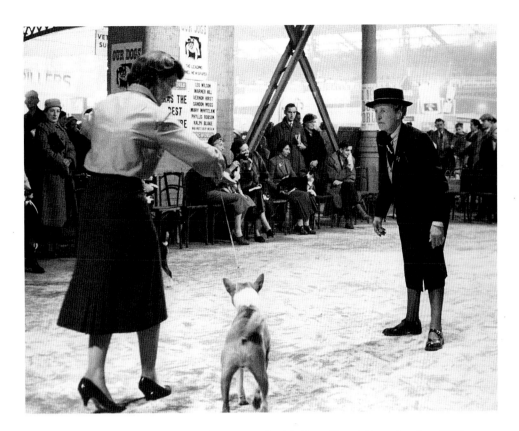

Tony Armstrong-Jones 'Olympia – Cruft's Dog Show' (from *London*, 1958)
(Originally photographed for *Queen*).

FACES WITHOUT SHADOWS

Young men who live for clothes and pleasure / by Peter Barnsley, photographs by Donald McCullin

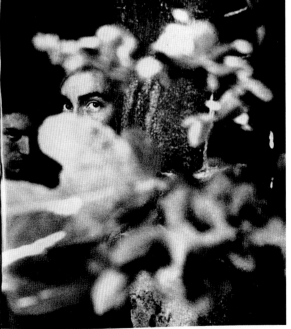

Mark Feld, Peter Sugar and Michael Simmonds were brought up in Stoke Newington. The most important thing in the world to them is their clothes: they have cupboards and shelves bulging with suits and shirts often designed by themselves in bright, strange and violent colours. In their vocabulary they, and the few other contemporaries of whom they approve, are described as 'faces' – the necessary ingredients are youth, a sharp eye for dressing, and a general lack of mercy towards the rest of the world.

Feld is 15 years old, and still at school. His family has just moved from Stamford Hill to a pre-fab out in Wimbledon. Of this he does not approve. The queues of Teds outside the cinemas in Wimbledon look just like a contest for the worst haircut, he says. At least the boys of old Stamford Hill dress sharply, and who would want a new, clean house if it is in unsympathetic surroundings? Nonetheless cleanliness is of vital importance to him. Shining with soap and health, he is apparently tireless and often goes for days on end without any sleep; there is never a trace of fatigue or boredom in his face. What is the point of all this energy and all the soap and water? Where is the goal towards which he is obviously running as fast as his impeccably shod feet can carry him? It is nowhere. He is running to stay in the same place, and he knows that by the time he has reached his mid-twenties the exhausting race will be over and he will have lost. Living for the present is a mild way of putting it; for him and for all the other sharp young faces the present is so short and so intensely satisfying that they cannot give even a minute of their time to considering the future.

Leading this sort of life develops arrogance. It is naturally assumed that all girls must fall headlong in love when they meet a face; those that are not pretty enough or who fail to come up to scratch in some way are referred to as maggots by the boys, and roundly insulted whenever

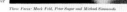
Three Faces: Mark Feld, Peter Sugar and Michael Simmonds

Town September 1962 'Faces Without Shadows' (photograph by Don McCullin).

59

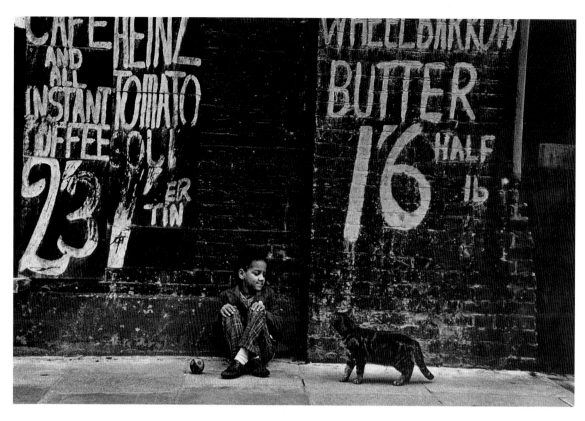

Don McCullin 'East of Aldgate' *About Town* February 1961.

High contrast was also adopted as a graphic shock tactic by the magazines themselves and Wolsey was a pioneer of the so–called 'soot and whitewash' school – an economy of tones: 'We could afford very little colour in *Town* and I was determined that the black and white photographs should stop people in their tracks. I worked directly with our Production Manager Denis Curtis and our printers to ensure we got the density in the blacks that was essential. It was very difficult to achieve an intense black on letterpress, but Denis managed it.' The uncompromisingly gritty presentation of features such as Don McCullin's dramatic, downbeat 'East of Aldgate' (*About Town*, February 1961) or John Bulmer's 'England's Hard Centre: The Black Country' (*About Town*, March 1961), its dramatic lead photograph bled off all sides of a double–page spread, is in marked contrast to the tentative layout, cosy stories, and banal imagery that had predominated in the illustrated magazines of the mid–1950s.

One of the most influential and widely respected art directors of the 1960s, Tom Wolsey, studied at Leeds College of Art and the Central School of Art and Crafts, and joined the W. S. Crawford advertising agency in 1955. Ashley Havinden, who had joined Crawfords in 1922, still presided over their art department. It was Havinden who had, in 1927, brought E. McKnight Kauffer into

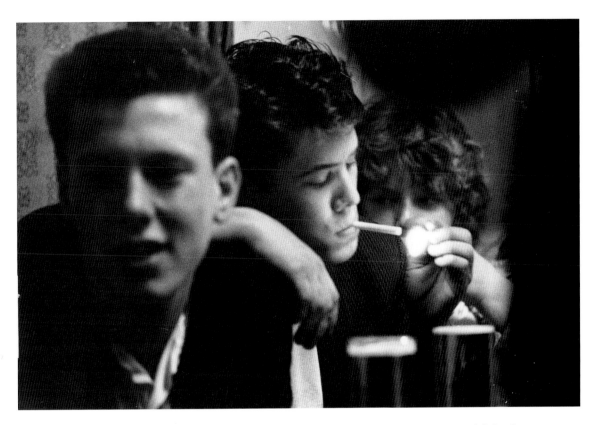

John Bulmer Nelson, Lancashire (for *Man About Town* January 1961, unpublished).

the firm, which through its Berlin agency had direct connections to the German New Objectivity photographers and designers. Wolsey maintained his links with advertising and at *Town* directed, unusually, many of the advertisements as well as the editorial pages. He used the same photographers for both – including David Bailey, Terence Donovan, and John Cowan – with the result that the men's fashion advertising is frequently hardly distinguishable from the editorials. When Wolsey moved to *Queen*, in 1963, taking over from Max Maxwell as art director, he simultaneously directed Jaeger's advertising account: shortly after this he opened an independent agency in partnership with Vernon Stratton, taking the Jaeger account and a percentage of their turnover. Traditionally, the creative freedom and lack of commercial constraints permitted in editorial photography had meant that, theoretically, it was superior to advertising photography. Wolsey, who was active in both spheres, was positioned at the inception of the process whereby the gap between the two narrowed to the point where, in magazines today, the distinction, at least in terms of image quality, hardly exists. For Graham Finlayson, photojournalism has become victim to a reversal of that process: 'In 1957 there was scope to experiment, you were allowed to be intuitive and photographing was an act of discovery. Now ideas are preconceived in the office by an art director – it is more like working to an advertising brief.'

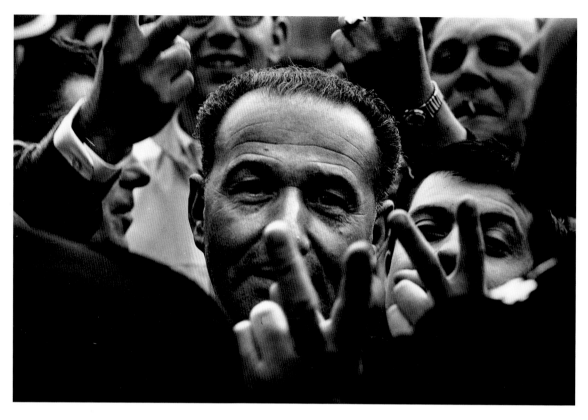

Don McCullin National Socialist Movement Rally *Observer* July 1962 (variant published).

Tom Wolsey was also art director of another Cornmarket Press magazine, *Topic*. Launched in 1961 *Topic* was bought by Heseltine and Labovitch in an unsuccessful attempt at establishing a 'British *Time* or *Newsweek*', and though it failed to survive beyond 1962, it provided commissions for Don McCullin, Philip Jones Griffiths and others. The patterns of employment for photojournalists almost invariably depended on assignments that originated with a sympathetic writer, editor or art director. An example of this is *Time & Tide*, an established non–party weekly that was not visually orientated (and therefore offered few opportunities to photographers), until Jan Pienkowski took over as art director in 1961. Under Pienkowski's direction not only were the magazine's graphics outstanding but he used photographs extensively, including the work of Roger Mayne, Philip Jones Griffiths, Patrick Ward, Euan Duff, and Anthony Howarth. On Pienkowski's departure, after little more than a year, the magazine reverted to its non–visual format, and a source of stimulating assignments was immediately sealed off.

Terence Donovan Golden Loin: The Secrets of an Agent *About Town* May 1961.

Don McCullin National Socialist Movement Rally *Topic* 14 July 1962 (also published in the *Observer*).

Don McCullin National Socialist Movement Rally *Topic* 14 July 1962.

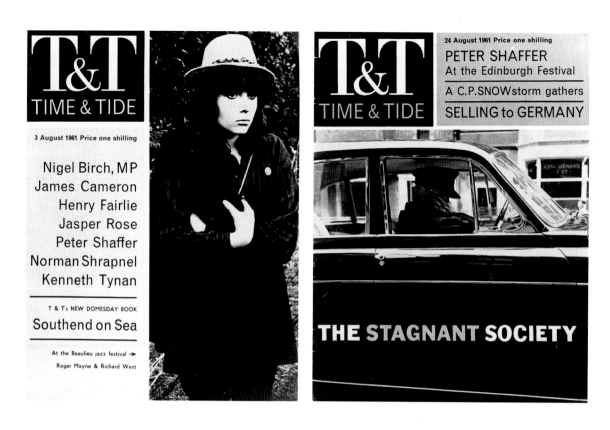

Time & Tide covers 1961 (photographs by Roger Mayne).

The revolution in graphic design in the 1950s provided the context for more innovative combinations of photography and typography and for the more imaginative layout and sequencing of photographs on the printed page. It was the art schools, in particular the Central School of Arts and Crafts and the Royal College of Art, that fostered this revolution, though the leading photographers, with the notable exception of Brian Duffy, who had studied painting and fashion at St Martin's, did not generally emerge from the art school system.

William Johnstone, former Principal of the Central School, recalled that 'During the fifties the very best students chose to study graphic design and typography rather than opt for the Fine Arts which seemed only to attract third- or fourth-rate students.' The modernist syllabus at Central School produced a high proportion of the graphic designers whose collaborations with photographers resulted in the most impressive advertising and magazine imagery of the 1960s. The School of Graphic Design at the Royal College of Arts, on the other hand, was founded in 1948 in the traditions of steel and wood-block engraving, fine bookbinding, and limited-edition private presses: the RCA's student magazine, *Ark*, is a valuable record of the reaction against this crafts legacy that was based at the intersection of graphics, painting, and photography.

Robert Freeman Len Deighton 1964.

Initially, the content of *Ark* was biased towards the whimsical folk nostalgia condemned by John E. Blake, editor of *Design* magazine and a former RCA student, as 'in tune with the Victorian revivalism that was a particularly unhappy mark of the Festival of Britain'. (*Design*, 175, 1963) Under Blake's editorship, art editor Ray Hawkey included photographs – greeted with horror by most of the staff – for the first time in *Ark* (5, Summer 1952). He also expressed a wish to join the editorial staff of a magazine on graduating, and, having won a *Vogue* talent contest, joined the *Vogue* art department in 1953. Design director of the *Daily Express* from 1959 to 1964, Hawkey, who went on to redesign the *Observer* and the *Observer Magazine*, was one of the most influential figures in modern newspaper graphics. He has stated that he was convinced of the fallacy of the RCA's anti–photography stance by exposure to the annuals of the Art Directors Club of New York, citing specifically the photography of Richard Avedon and Irving Penn, and the art direction of Alexey Brodovitch and Alexander Liberman. Hawkey's friend Len Deighton was art editor of the spring 1954 issue of *Ark*: not only did Deighton design the magazine's first photographic cover, he was also, as Alex Seago has noted, the first of many RCA graphics students to make the pilgrimage to New York.

In challenging conservative attitudes to photography, Hawkey and Deighton were pioneers of the 'new breed' of art editors and designers, forging the symbiotic relationship of the disciplines in magazines and advertising. One of countless instances of the re–diffusion of the these formative experiences, former *Ark* art editor Gordon Moore became art editor of, successively, *Woman's Own*, *Queen* (under Mark Boxer) and the first art director of the *Sunday Times Colour Section*, before leaving for New York where he worked as picture editor of *Playboy* and *Oui*.

British graphic design, a synthesis of the 'immaculate technique' and discipline of Continental modernist graphics with the energy of American mass media imagery, was also informed by the art school rebellion in painting and by contemporary developments in photography. Ken Garland, art director of *Design* from 1956 until leaving to freelance as a designer and photographer in 1962, studied photography (which he described as 'kind of an orphan subject, tucked away in the basement') in Nigel Henderson's class at the Central School in 1952–53. Garland credits Henderson with introducing students to Moholy–Nagy's seminal primer, *Vision in Motion*: 'I wasn't put on to that by a graphic design teacher but by Nigel.' Henderson's photograms were published in *Ark*, as were Roger Mayne's street photographs, but the RCA did not set up a photography department until 1968, under John Hedgecoe. And although in 1956 Geoffrey Ireland was appointed tutor in charge of photography within the graphic design department, photography was principally regarded, under staff photographer R. L. Jarmain, as a

Dermot Goulding 'Man In Chains, off Lisle Street' London *Ark* 23 (Autumn 1958).

recording and printing service for students and other departments. Steve Hiett (art editor with Roy Giles of *Ark*, 36, Summer 1964) recalls that it was the graphics students with the lively interest in the potential of photography, whereas most photography students were considered boring technicians. Hiett transferred to the RCA from Brighton College of Art, where his main influence had been the teaching and encouragement of Dermot Goulding, previously assistant to Ireland and Jarmain at the RCA. Goulding, a sensitive photographer whose work was published in *Ark* and by Tom Wolsey in *About Town*, is recalled by Hiett as an inspirational figure: 'Dermot would come in to college and thrust down on the table a copy of *Twen*, Robert Frank's *The Americans*, or William Klein's *New York*. He opened our eyes. Seeing Klein's photographs for the first time was like the first time you heard Chuck Berry's Maybellene.'

Hiett, like Brian Duffy, became a successful fashion photographer, but the three year hiatus between the fall of *Picture Post* in 1957 and the relaunching of *Man About Town* in 1960 was a lean period for photojournalists, and would have been more difficult without syndication agencies and daily, and Sunday, newspapers. The most sympathetic users of photojournalism among these were the *Observer* and the *Manchester Guardian* (the Manchester was dropped

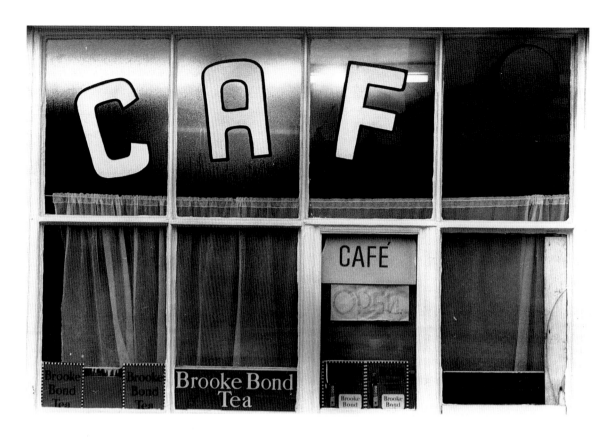

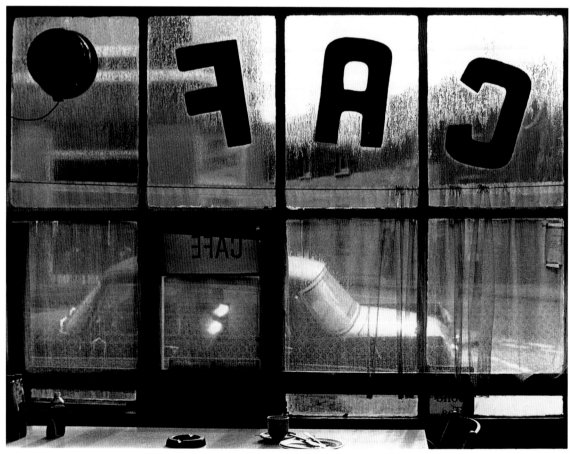

Dermot Goulding Caf 1964.

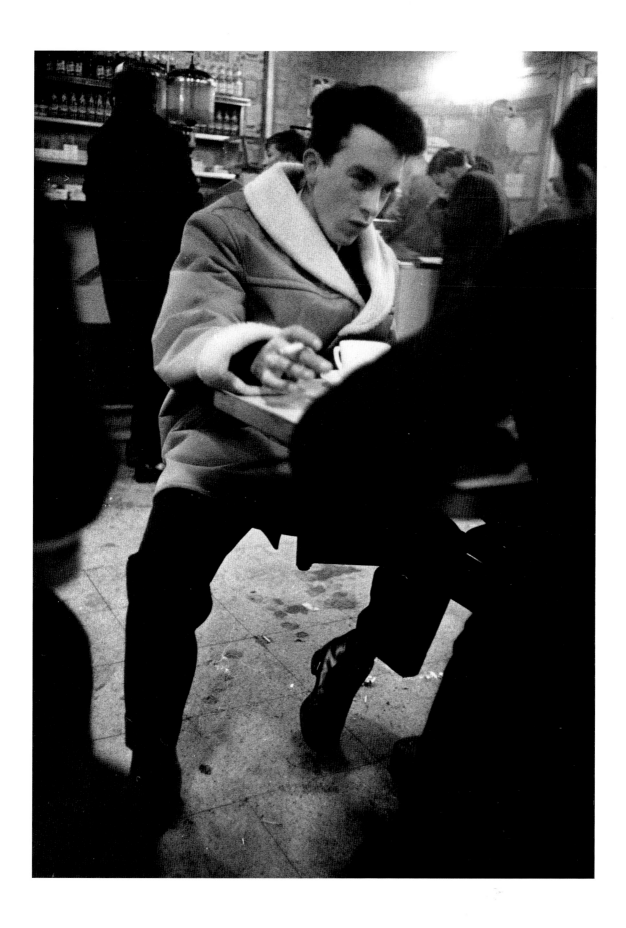

John Bulmer Nelson, Lancashire *Man About Town* January 1961 (unpublished).

from the title in 1959, although an editorial office was maintained there until 1964). Graham Finlayson, the most prominent *Guardian* staff photographer, moved to London in 1963 to freelance; Neil Libbert was also based in Manchester in the late 1950s, and, though not on the staff, was a prolific and distinguished contributor.

At the *Observer*, Jane Bown and Michael Peto had both been established as staff photographers since 1949. Jane Bown, and Grace Robertson of *Picture Post*, were the only women to make a significant contribution to photojournalism in the 1950s. Peto, though strictly speaking outside the remit of this study (he was born in Hungary), was not only a talented and sensitive photographer, but also greatly encouraged many younger photographers, including David Hurn (who, like Peto, was attached to Peter Tauber and George Vargas's agency 'Reflex' in the late 1950s) and others at the *Observer*, including Peter Keen and Bryn Campbell (both of whom were also picture editors), and Colin Jones. Philip Jones Griffiths and Don McCullin were both regular contributors to the *Observer* in the early 1960s, along with several other excellent photographers, including Stuart Heydinger and David Newell Smith.

It is significant that the second wave of photojournalists to emerge from Cambridge (after Tony Armstrong-Jones and Anthony Howarth) envisaged a magazine as the logical expression of their interests. *Image*, launched in 1960, was conceived by photographers John Bulmer and Peter Laurie, and writer Brendan Lehane. The university's curriculum did not include photography, and Bulmer was reading engineering and Laurie mathematics and then law. The magazine featured photography prominently and, in spite of a tight budget and small circulation, managed to attract both advertising and budding London photojournalists of the calibre of Philip Jones Griffiths and Don McCullin. All the principals agree that *Image* was mainly established as a means to ensure that the staff would secure a conducive job in London. John Bulmer duly joined the *Daily Express* as a photographer in 1960, he was soon freelancing for *Man About Town*, and was one of the leading photographers at the *Sunday Times Colour Section* from its inception in 1962. Brendan Lehane joined *About Town* as Features Editor and Peter Laurie became features editor–cum–photographer at *Vogue* in 1961: 'At the time of *Beyond the Fringe*,' says Laurie, 'almost everyone in the media believed that the key to success was to employ people from Cambridge. *Vogue* even sent a deputation up to Cambridge to scout for talent.' Christopher Angeloglou succeeded to the editorship of *Image* in 1961; he joined the *Sunday Times Colour Section* as picture editor in the following year, combining this with quite frequent forays as a photojournalist for the magazine.

In 1962 the opportunities available to photojournalists increased with the birth of the *Sunday*

Michael Peto 'Families affected by unemployment' *Observer* 1959.

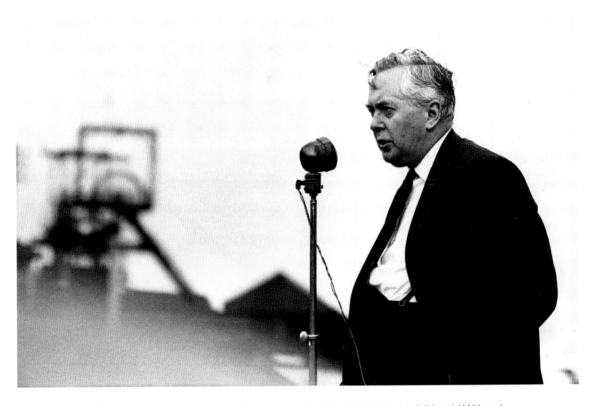

Christopher Angeloglou 'Notes for a Profile of a Politician' (Harold Wilson)
Sunday Times Colour Magazine 9 February 1964.

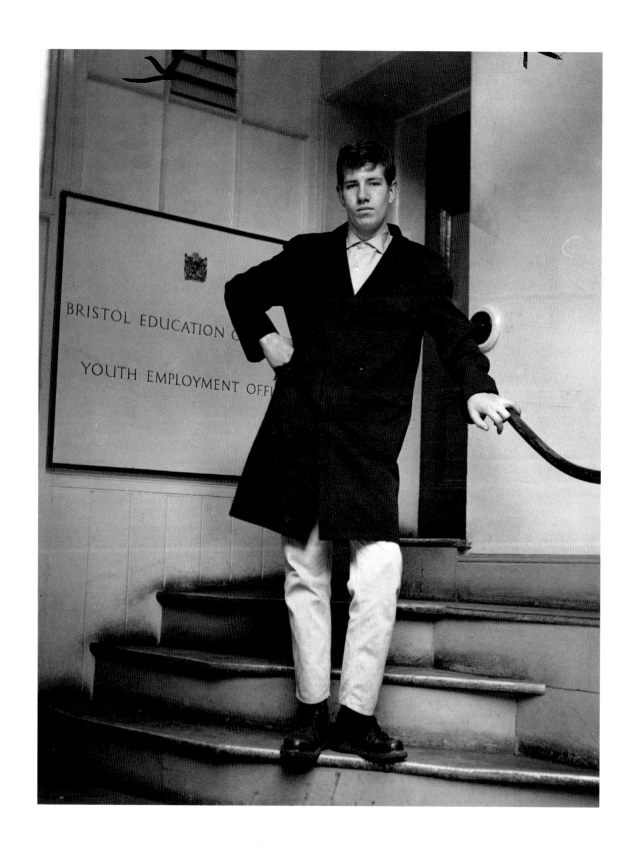

Jane Bown 'People Without Jobs' (Bristol) *Observer* 22 February 1959 (unpublished).

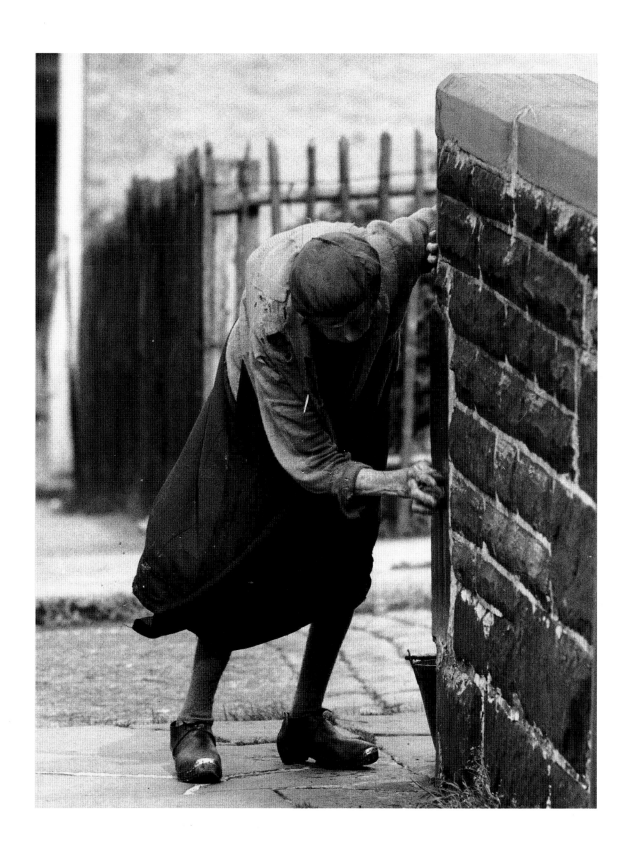

John Bulmer Nelson, Lancashire *Man About Town* January 1961.

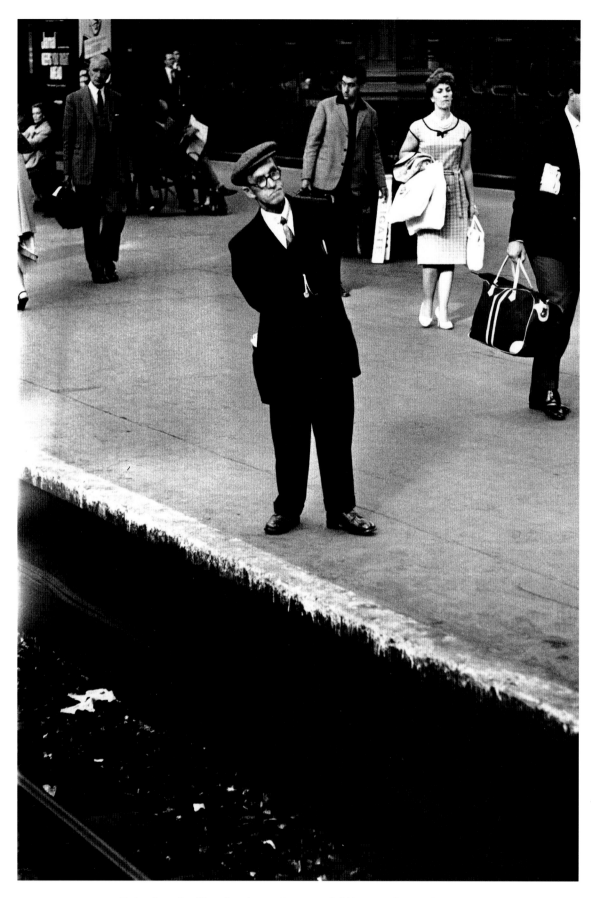

Peter Laurie 'People who are just people' *Vogue* 1 December 1961.

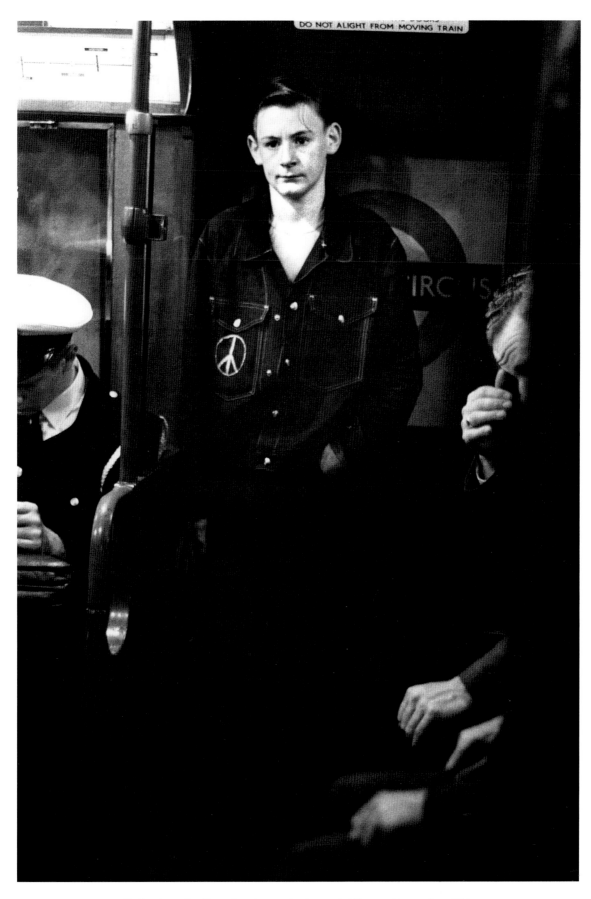

Peter Laurie 'People who are just people' *Vogue* December 1961.

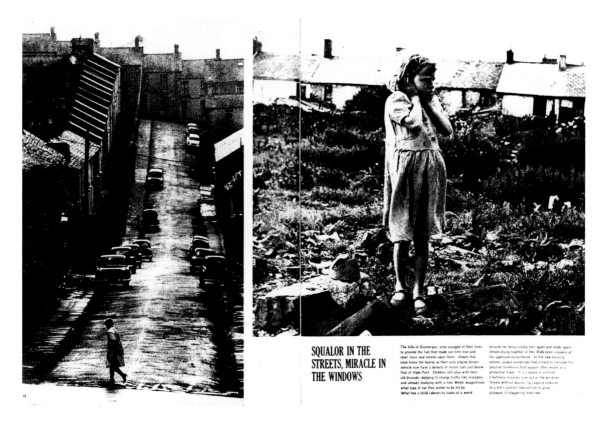

SQUALOR IN THE
STREETS, MIRACLE IN
THE WINDOWS

'How Welsh is Wales?' *Sunday Times Colour Magazine* 17 November 1963
(photographs by Philip Jones Griffiths).

Times Colour Section. After the initial hostility from rival proprietors had subsided, the *Observer Magazine* and the *Weekend Telegraph Magazine* followed and were launched in 1964. Although the staff who pioneered the *Sunday Times Colour Section* (it became the *Sunday Times Colour Magazine* in February 1963) were allowed considerable editorial freedom, the motives behind the magazine were overtly commercial: it would be another four years before television was broadcast in colour in Britain and the initiative was aimed to tap the lucrative potential of full–colour upmarket advertising. This dictated the magazine's editorial mix of product–orientated features with political journalism. For Michael Rand, who became art director of the colour supplement in 1963, following the departure of Gordon Moore, 'Dennis Hamilton was the great man of the *Sunday Times*. Dennis was a benevolent figure who had the ear of the government, and when he would quietly say that we must do something to help boost car exports, even Mark [Boxer] realized we would have to do a feature about cars.'

Shortly before the September 1964 launch of the *Observer Magazine*, David Astor reassured an interviewer that the planned onslaught on their competitors' advertising revenue would not diminish editorial independence: ' ... the advertiser is not primarily interested in what we say –

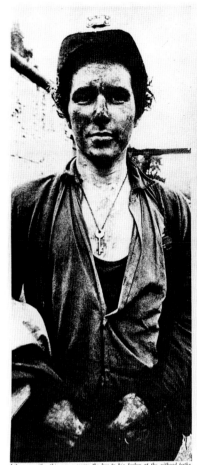

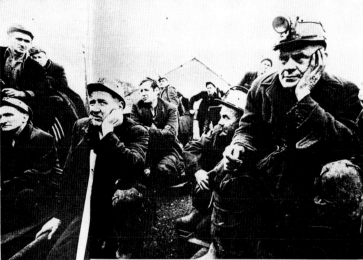

Before going below ground to begin the afternoon shift a group of middle-aged miners meet to listen to the latest news of redundancies for pits that are closing.

continued / alternative source of work. In two years the largest remaining colliery, at Cefn Coed, may close, displacing another 1,000 men.

More than a century of industrial exploitation has drained the valley of every vestige of colour. Great alps of coal rear up sheer from the roadsides, and the threadbare covering of grass that carpets the hillsides is worn thin in patches to reveal the black earth beneath. A few stunted trees hump their backs against the prevailing wind, and across the way from the disused colliery Onllwyn No 1 the empty doorways and windows in deserted cottages gape like missing teeth. Sheep, grey with coaldust, nose optimistically among derelict buildings at the deserted pithead.

But the surface of the valley, rugged as it is, gives only a hint of the layers below, where men toil, often on their knees, to win the best anthracite in the world. Coal seams are narrow and often turn back on themselves like

folds in a blanket, or vanish abruptly. Under such conditions mechanisation has proved difficult and coal is extracted expensively. Last year the Coal Board lost 37s. on every ton mined there.

A lifetime of fighting the seams of the valley and the coal owners has made the men of Dulais politically left, and natural protesters. No Cardiff demonstration against Panzers in Pembrokeshire or nuclear weapons would be complete without them. Anyone who asks one of them why they are unwilling to move to another part of the coalfield or even to another job is liable to be asked "Why should we! We are not bloody Gipsies, are we!"

As they come up blinking into the afternoon light at the end of a morning shift, the men of the Dulais Valley look much the same as miners anywhere. Their black faces, with white eye sockets and lips, give them the appearance of a photographic negative. In fact they are as different from the men in neighbouring valleys, *[continued*

'Black faces, with white eye sockets and lips, like a photographic negative.'

Like a crucifix, this miner wears the key to his locker at the pithead baths.

'The Dying of Dulais Valley' *Observer Magazine* 7 November 1965
(photographs by Colin Jones).

he is interested in reaching our readers'. Nevertheless the proximity of advertising and editorial matter in the colour supplements was far more blatant than the limited boxed advertisements found in predecessors like *Picture Post*. The reporting, in dramatic and disturbing photographs, of third world tragedies and international conflicts in the Sunday magazines in the later 1960s, raised protests against the insensitive juxtapositioning of consumer advertising and harrowing images of suffering. The ensuing debate confirmed the polarization of the opposing interests of advertising and reporting, and the increasingly sophisticated political reading of photographs ensured that photojournalism would not continue to sit so easily in glossy periodicals supported by advertising revenue.

Prior to the launch of the *Sunday Times Colour Section* in 1962 there was little photojournalism in colour in Britain. Advertisements were predominantly black and white and neither *Vogue* nor *Town*, for example, although their covers were invariably printed in four colours, contained more than eight full colour editorial pages. The switch to colour was, therefore, quite sudden and few photographers were prepared for it.

John Bulmer was recognized immediately for having made the necessary adjustment and thinking specifically in terms of colour, and became one of the most prolific contributors of colour reportages to the *Sunday Times Colour Section*. Many of Bulmer's most important assignments were abroad, but he was also acknowledged as an adroit recorder of provincial Britain. His reputation as a photographer of the industrial cityscape was probably gained at *Town*, where he was responsible for stories on Nelson, Lancashire, the Black Country, and 'The North is Dead'.

John Braine, whose novel *Room at the Top* (1957) sparked the fascination with the mythical North, grew to resent his geographical confinement as a 'Northern writer' as well as the narrow and romanticized version of the north accepted as social realism in the south. The visual image of the north was codified by British New Wave cinema, in a spate of films such as Jack Clayton's *Room at the Top* and Karel Reisz's version of Alan Sillitoe's *Saturday Night and Sunday Morning*; from 1960 Granada Television's apparently immortal *Coronation Street* began its broadcasts to an even larger audience.

For John Bulmer the industrial landscape was both fascinating and, he readily admits, exotic; ultimately, though, he found the voyeuristic aspect of social reportage problematical and the time constraints on a weekly magazine frustrating. He undertook these documentaries, at a point when it was becoming clear that Britain's industrial base was rapidly contracting, in the spirit of recording a way of life that was rapidly disappearing. His strikingly beautiful colour photographs depict the urban north from an affectionate and arguably less biased viewpoint than the more familiar images of austere monochrome depressiveness.

(opposite) **John Bulmer**
All photographs taken for the *Sunday Times Magazine* 28 March 1965 (top left image only published).

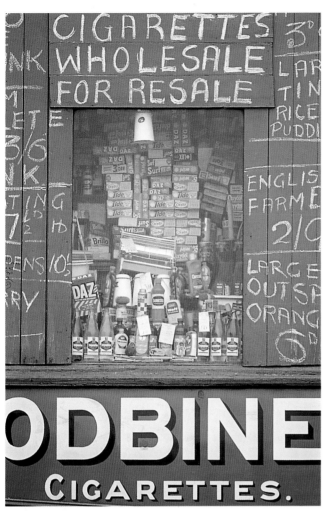

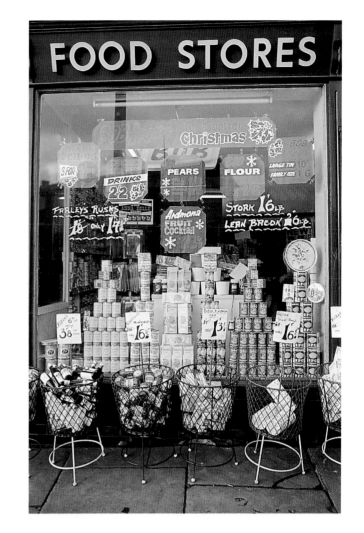

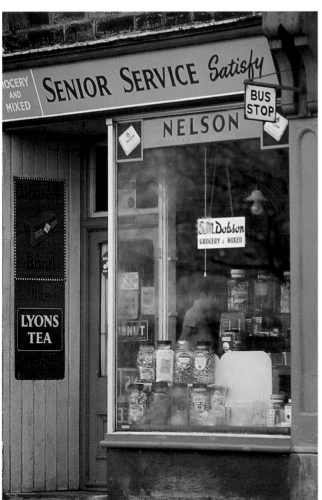

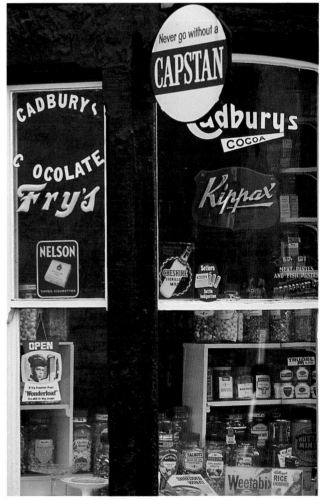

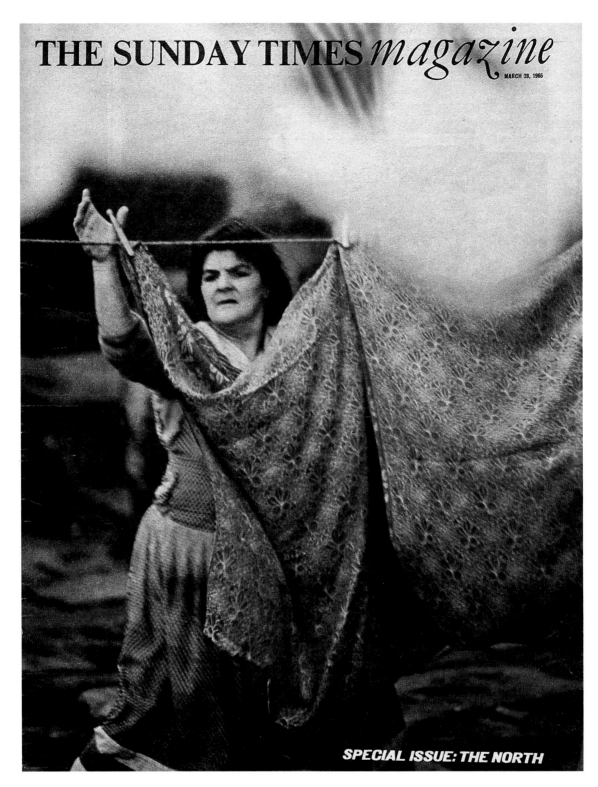

THE SUNDAY TIMES *magazine*

MARCH 28, 1965

SPECIAL ISSUE: THE NORTH

Sunday Times Magazine 28 March 1965 (photograph by John Bulmer).

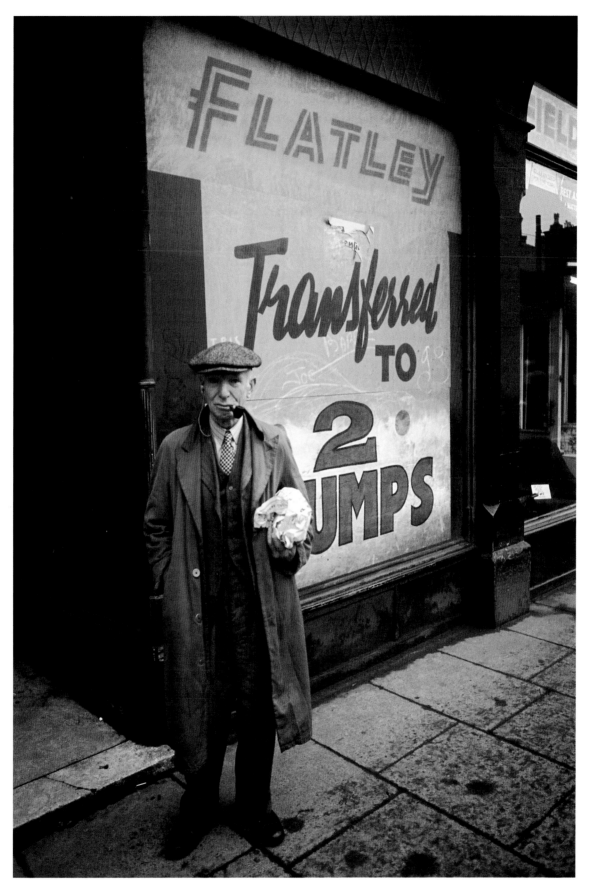

John Bulmer Oldham, Lancashire 1961.

(overleaf) **John Bulmer** Leeds, Yorkshire, *Sunday Times Magazine* 28 March 1965 (variant published).

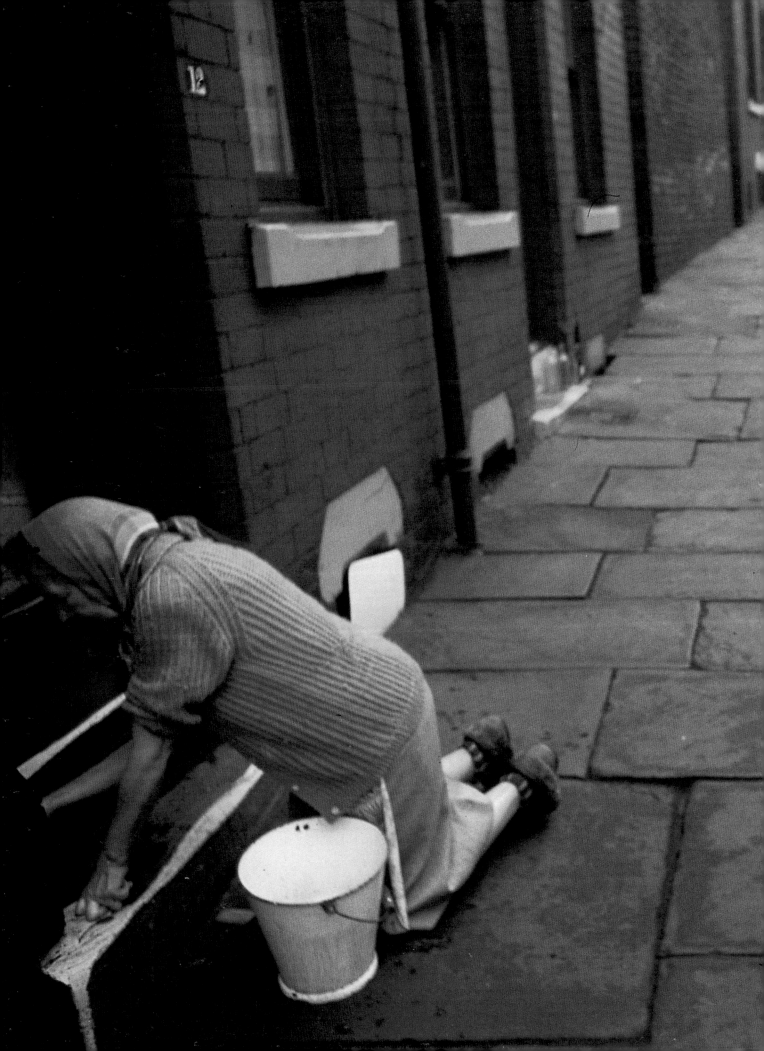

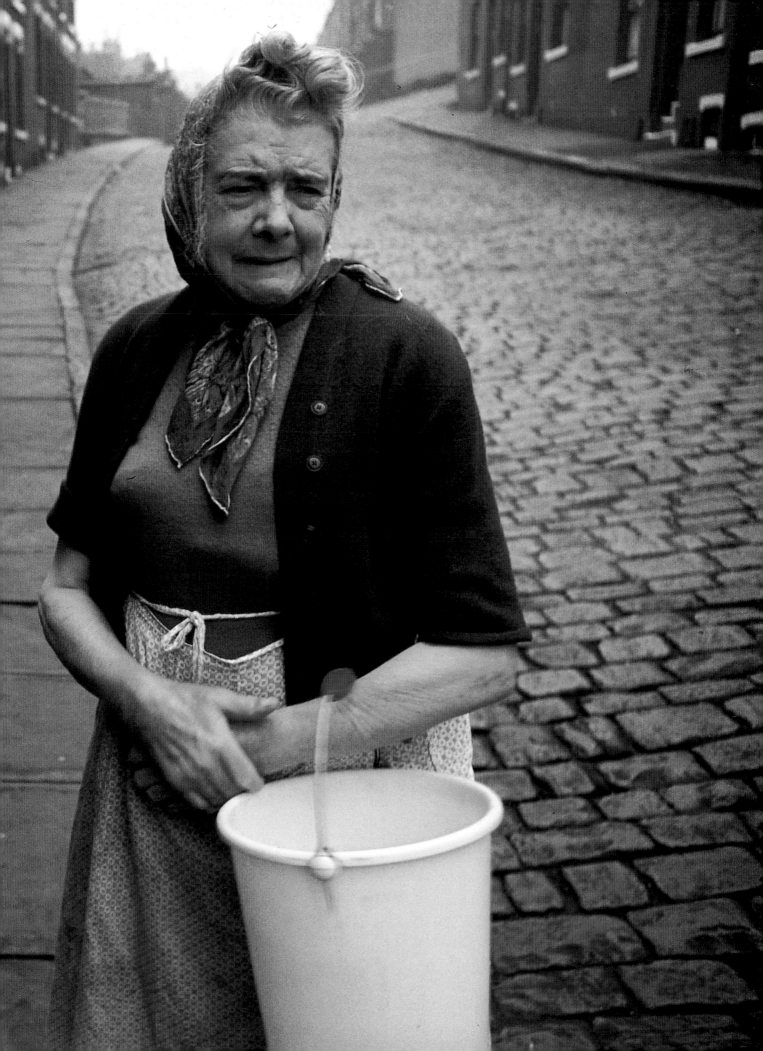

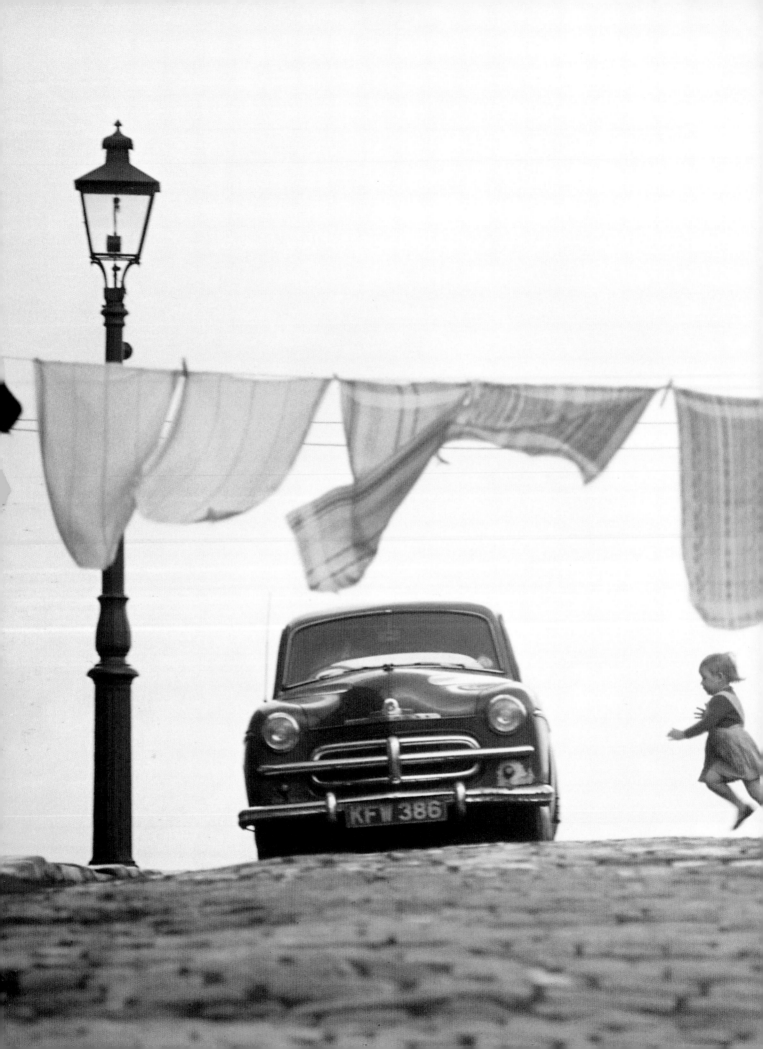

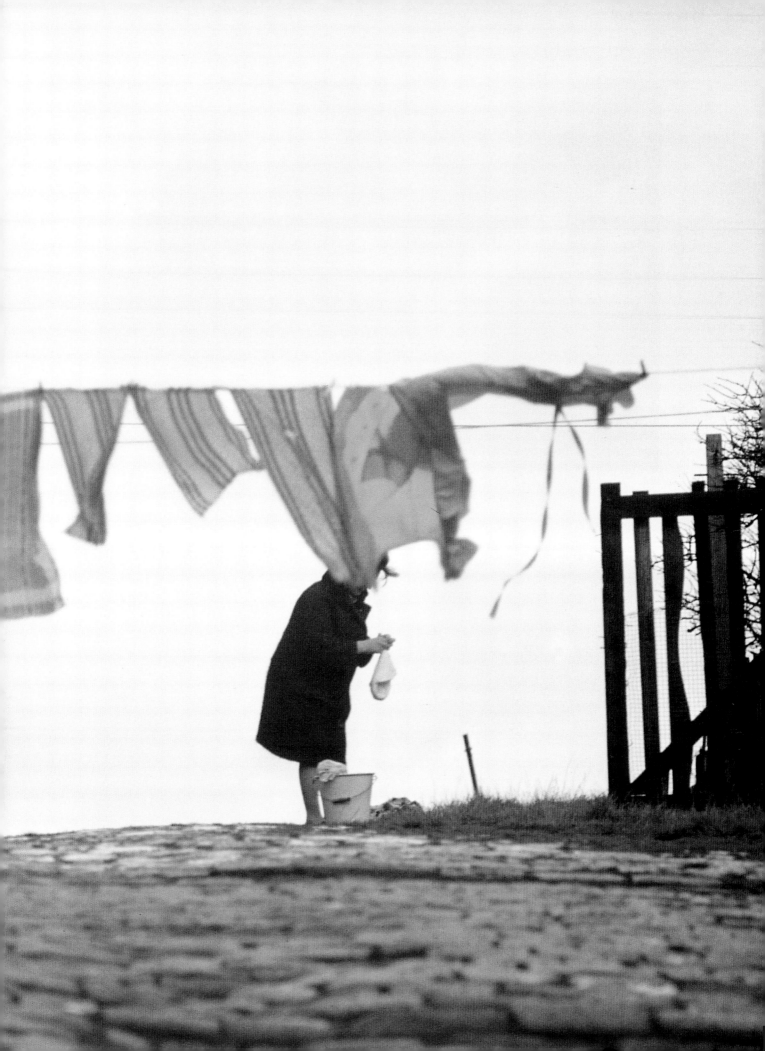

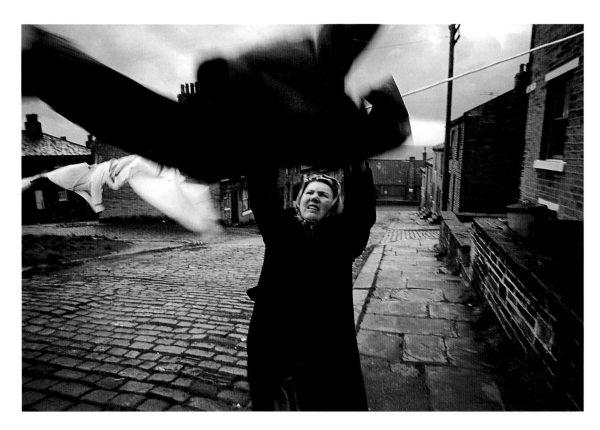

(above and below) **John Bulmer** *Sunday Times Magazine* 28 March 1965 (unpublished).

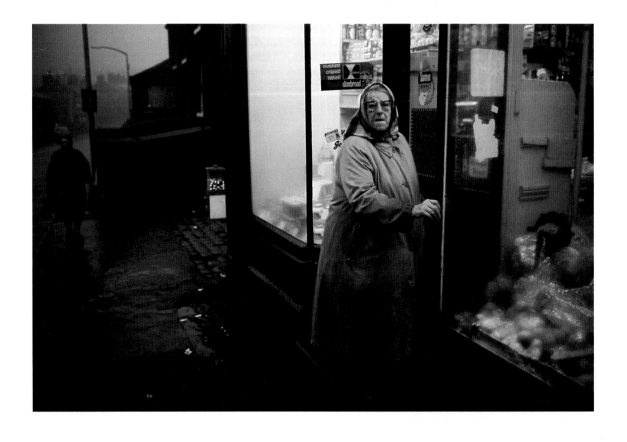

(preceding pages) **John Bulmer** *Sunday Times Magazine* 28 March 1965 (unpublished).

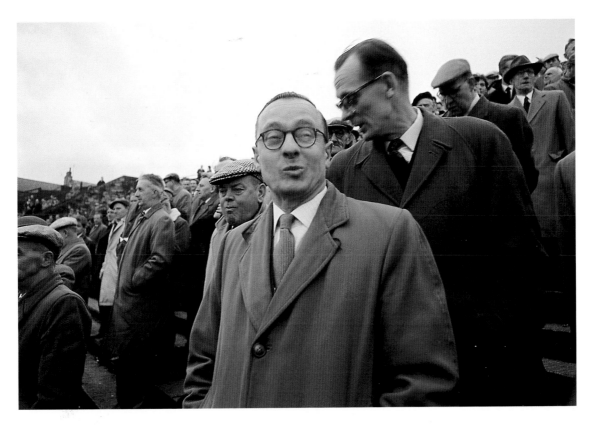

(above and below) **John Bulmer** *Sunday Times Magazine* 28 March 1965 (unpublished).

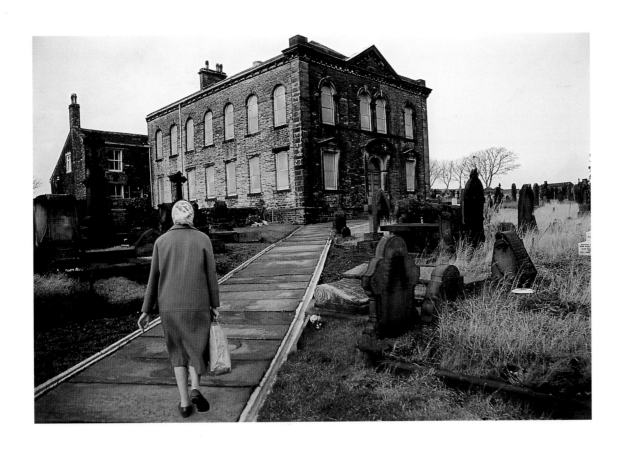

John Bulmer
Liverpool 1961.

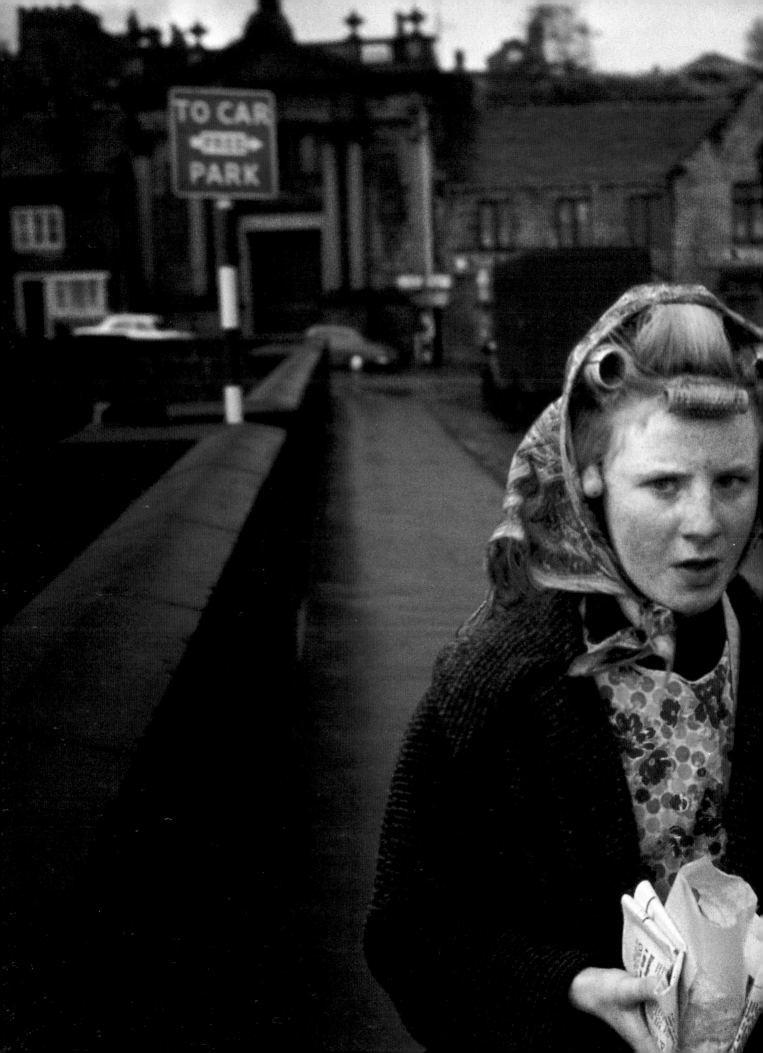

John Bulmer
Elland, Yorkshire
Sunday Times Magazine
28 March 1965.

'Dirty' Dominic Pye and his father 'Dirty' Jack Pye. Jack, a retired wrestler, has stopped throwing referees out of the ring and opened a casino. Dominic followed his father into the ring and inherited his title; runs an antique business on the side.

Blackpool: chicken for all on Thursdays
by Peter Dunn

In Blackpool the big gesture counts almost as much as making a fortune or organising a day out for the old folk. 'Dirty' Dominic Pye, a massive wrestler with sunglasses and slow-burning Havana, once clean-and-lifted a Polish tram-driver's three-wheel car because it was parked in his way. Pye, whose father, Jack, retired from wrestling two years ago and now runs the Castle Casino on the North Promenade, said: "It cost me £120 between fines and costs but with the publicity from the ITV it was worth it in actual fact."

Graham Finlayson *Sunday Times Magazine* c.1965.

Robert Freeman *Sunday Times Colour Magazine* 2 August 1964.

Robert Freeman *Sunday Times Colour Magazine* 2 August 1964.

Image, issue 5 (1961, photograph by Chris Angeloglou).

Sunday Times Colour Section
(1962, undated photograph by John Donat).

Go! June 1961 (stock photograph).

Town August 1962 (photograph by Terence Donovan).

In the early 1960s British magazines began to reflect the new symbiosis of graphic design and photography. The Young Meteors who had cut their photographic teeth in the late 1950s were ready to take their place as image-makers to the mass media. Suddenly the situation was wide open. Boundaries between different disciplines were dissolved in the polyglot context of a society edging into a new era. Seldom since that time has it been possible to find, in the pages of the same magazine, the sharp elegance and tenderness of a David Bailey photograph together with the grit and raw emotion of a Don McCullin. Simultaneously, Pop art was briefly triumphant and British photographers, painters, musicians and designers were at the centre of world attention. Informed by the new spirit of cross-media integration, British photography had finally thrown off its inferiority complex and emerged from its black hole.

Most of the Meteors would normally be defined as photojournalists, but David Bailey and Terence Donovan are more often categorized as fashion photographers. In 1960, these distinctions were less important. Few photographers who eventually specialized in fashion began their careers with that aim. David Bailey, for example, first became seriously interested in photography in 1957, while serving in the Royal Air Force. He has cited Cartier-Bresson's atmospheric and richly textural photograph of four women at Srinagar, Kashmir (1947) as the specific image that ignited his passion for photography. This is not what is usually termed a fashion photograph. Bailey happened to be temperamentally suited to the world of fashion and it was no surprise that he gravitated successfully in that direction, but it was not his original intention.

Bailey's output in the period between 1957 and 1965 was by no means limited to fashion photography; besides a high proportion of portraits it included both commissioned and self-motivated assignments that were informed by his interests in film and in photojournalism. Bryn Campbell perceived this connection in the first published article on Bailey (*Practical Photography*, January 1960), based on an interview conducted while Bailey was still an assistant at the John French Studios. In comparing Bailey with another John French protégé, Gerald Wortman, Campbell noted their respect for Cartier-Bresson and Eugene Smith, as well as for Avedon and Penn, and observed that of the two it was Bailey's work that 'gained from acquaintance' with photo-reportage. The grafting of the techniques of documentary realism onto high style photography was manifest during a specific and brief period beginning near the end of 1961, when Bailey first acquired a 35mm SLR camera. In two fashion essays, 'Point to

Don McCullin (Chapel Street Market, Islington, London) *Vogue* January 1961.

David Bailey 'New York: Young Idea Goes West' *Vogue* 1 April 1962.

David Bailey 'Point to Pointers' *Vogue* 1 February 1962.

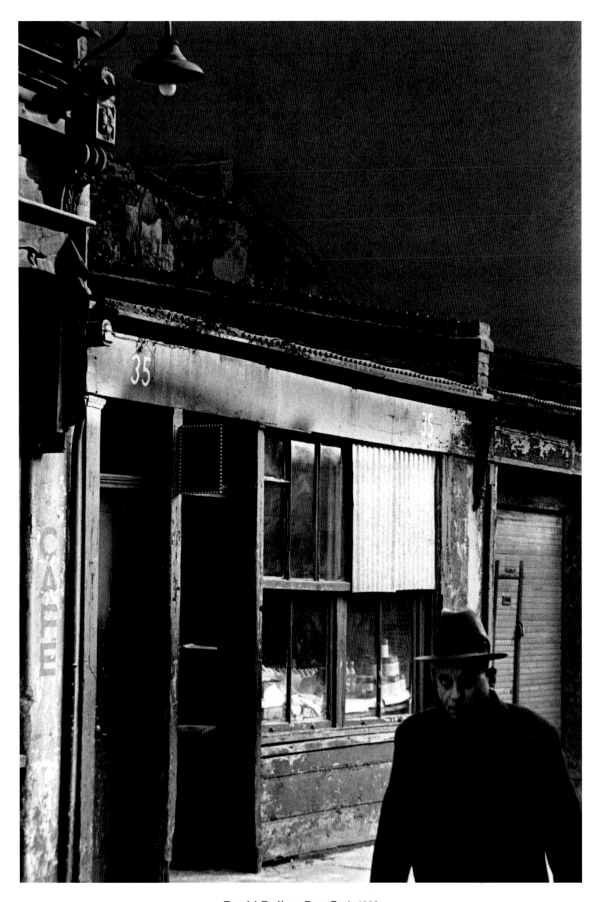

David Bailey East End 1962.

Terence Donovan 'The Lay About Life' *Man About Town* December 1960 (unpublished).

Pointers' (*Vogue*, 1 February 1962) and 'New York: Young Idea Goes West' (*Vogue*, 1 April 1962),
Bailey located his models in outdoor situations in which passers-by were a compositional
element left open to chance – a semi-photojournalistic approach to fashion photography.
Concurrently with these experiments in informality for *Vogue*, Bailey was spending the
weekends in the East End of London, documenting the inhabitants and the buildings of the area
in which he had grown up in an extensive series of photographs whose principal object was to
record a rapidly changing urban environment.

Terence Donovan, too, at the outset of his career, was employed by *Town* magazine as much for his
social reportages as for his notably revisionist depictions of men's fashions; the latter were often
conceived around a loosely structured narrative and laid out by Tom Wolsey in the manner of a
news-journal story. Donovan's work for *Vogue* and *Queen* was largely restricted to fashion and
portraits, but the range of his contributions to *Town* was wider. He was seldom comfortable in
relinquishing his directorial role, but in remarkable essays such as 'The Lay About Life' (*Man About
Town*, December 1960) and 'Strippers' (*About Town*, July 1961) he came close to photojournalism.

Terence Donovan 'The Lay About Life' *Man About Town* December 1960.

By 1962, Bailey and Donovan operated in an international arena and were increasingly aware of the highly professionalized support systems available to some of their competitors, in particular the leading Americans. In a rationalization of their working procedures they gradually eliminated high-risk strategies such as informal 35mm outdoor fashion reportage; they frequently worked on location, as well as in the studio, but it was within more tightly structured limits. However, in evolving the clear, graphic style for which they became renowned, they continued to experiment within this format – with lighting and gesture, for example – as exemplified in Bailey's photographs of his model, Sue Murray, and in Donovan's of Celia Hammond. Outside of the professional sphere Bailey never forsook the portable 35mm camera: his photograph of Catherine Deneuve and Agnes Varda (actually a half-frame image) on the set of Varda's film *Les Creatures* is typical of his continuing diaristic interests, which formed the basis of three books he would publish in the 1970s. Bailey was already a media celebrity by 1962, and Britain's most publicized photographer; in Antonioni's film, *Blow-Up* (1966), the apotheosis of London's fashion photographers, the incidental details were based on the lives of Bailey, Donovan, and Brian Duffy.

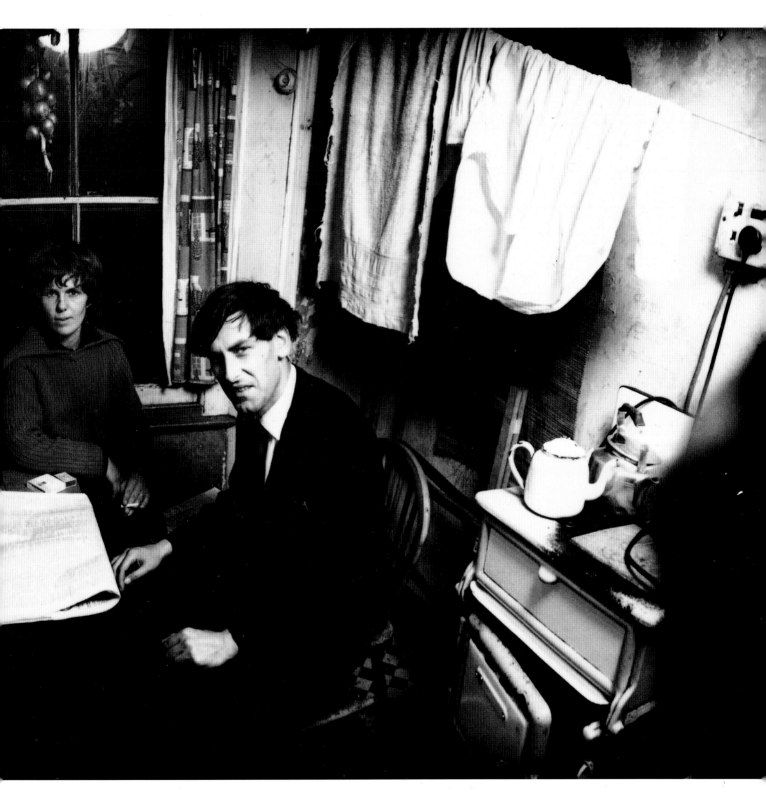

Terence Donovan 'The Lay About Life' *Man About Town* December 1960.

Terence Donovan 'The Lay About Life' *Man About Town* December 1960.

(overleaf) **Don McCullin** 'Fonthill Road, Finsbury Park' 1960.

Philip Jones Griffiths Adrian Henri, Liverpool 1961
(variant published in *Town* December 1963).

The documentary photographs taken by Thomas, Antonioni's photographer in *Blow-Up*, were actually Don McCullin's 'East of Aldgate' story, originally photographed for *About Town* in 1961. McCullin resisted offers to photograph fashions, but his reportages appeared regularly in *Town* and several of his earliest photographs were published in *Vogue*. Rigid photographic categorizations were blurred in the complex cultural contexts of the new media. Macmillan's Britain, despite social inequalities and the threat of nuclear annihilation, was not a strife-torn cauldron of unrest. But Don McCullin strongly identified with the under-privileged and sought out situations of political turbulence or the forgotten minorities of Britain's underbelly in the urban wastelands. In an interview for *Photography* magazine (June 1959), before he had turned fully professional, McCullin was reminded that photojournalists 'are sent to noisy places and occasionally get shot for the sake of their work': 'That,' he responded prophetically, 'is for me.'

McCullin's images were the most visceral and emotionally charged of any of his contemporaries. Unrivalled at capturing the tension and aggression of an inherently violent event such as a fascist rally, this dark observer of society was equally capable of wrenching a sombre elegy from a car parked in a London street. A Buick convertible sits, dense black with

Philip Jones Griffiths Calais 1961.

sleek chrome trim, an alien presence, a beached whale, in the crepuscular Victorian gloom of a Finsbury Park terrace reminiscent of a Stevie Smith poem. The formal geometry of McCullin's side-on depopulated view intensifies the strangeness, the cultural clash, as this hulk of 'shiny barbarism' invades a North London suburb. A potent symbol of the new affluence (the car belonged to a black boxing champion who had recently moved into McCullin's home street), this is not an unequivocal greeting for Reyner Banham's American consumerist utopia: McCullin has pitched his exposure at the bottom of the sensitometric curve to create an image that vividly describes ambivalence and anxiety at the onset of the 'consumer society'.

Of all the Meteors, Philip Jones Griffiths was the most politically motivated. Left-wing, a pacifist, his photography is above all compassionate, even when recording the devastation and inhumanity of a senseless war. Cartier-Bresson said that 'Not since Goya has anyone portrayed war like Philip Jones Griffiths': the inclusion as a coda to this volume of the harrowing 'Dead Vietcong, Vietnam, 1967' points to the international sphere in which many photojournalists increasingly operated after 1965 and is a reminder that their early British photographs represent only a small proportion of their significant work.

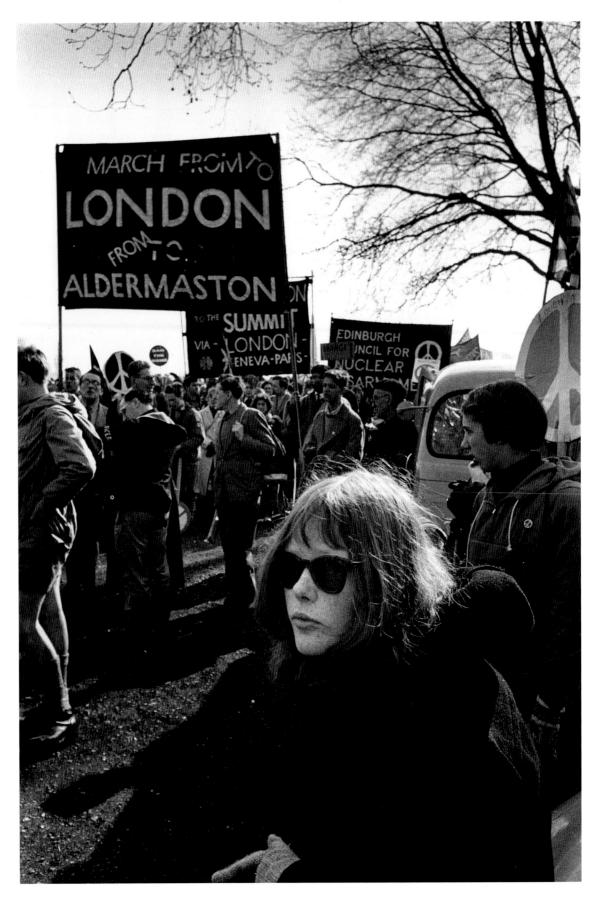

Philip Jones Griffiths 'Aldermaston March' *Guardian* 1960.

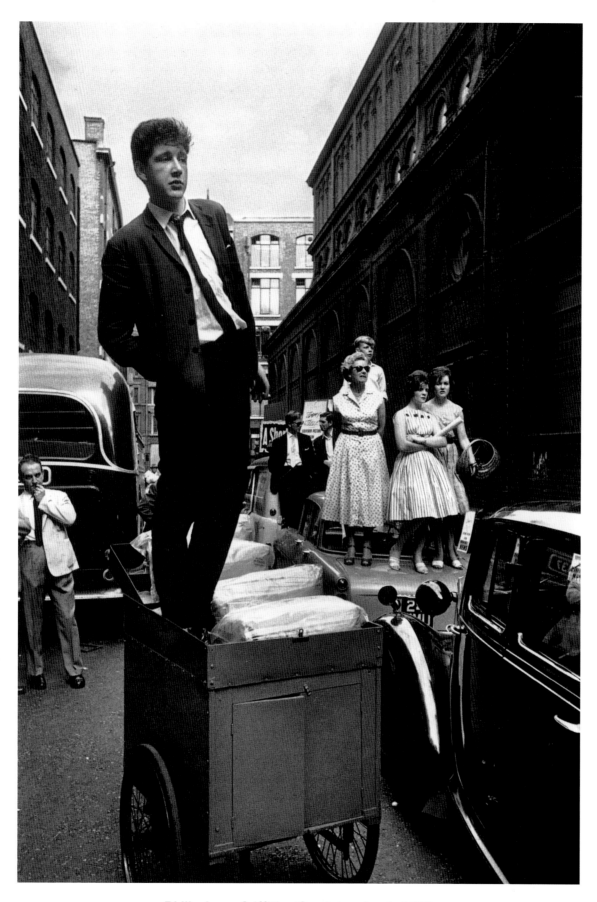

Philip Jones Griffiths 'Spectators, London' 1959.

Ken Russell 'Teddy Girl Iris Thornton and Friends' Plaistow, Essex 1955.

Even at school in his native North Wales, Jones Griffiths would 'earn a few shillings' photographing weddings, and in 1953 his first news photograph was published in a local newspaper, the *Rhyl Leader*. He trained as a pharmacist, but while studying in Liverpool he continued in his endeavours to have his photographs published. In the November 1956 issue of *Photography* he was described as 'an amateur, [whose] work has the professional touch'. By 1957 his work was being syndicated by Pictorial Press and he had developed a useful sideline in stage photography. Finally, in 1961, Jones Griffiths, encouraged by the support of Dennis Hackett, features editor of the *Observer*, felt confident enough to give up his job as night manager of a Piccadilly Circus chemist's and become a full-time professional photographer.

As an active supporter of the CND, Jones Griffiths naturally covered their annual anti-nuclear marches from Aldermaston to London: the final destination of the rallies, Trafalgar Square, became a meeting place for Young Meteors, who would repair to Jones Griffiths's flat in Goodge Street to discuss photography. As the most experienced of the group, Jones Griffiths was a beneficent influence on the early careers of John Bulmer, Christopher Angeloglou, Don McCullin and Peter Laurie. In his book *Dark Odyssey* it is clear that Jones Griffiths's

David Hurn 'Sisters of Mercy, London' 1962.

passionate political and social beliefs continue undimmed, yet, as his photographs consistently demonstrate, this ardour is filtered through a humane and generous spirit.

Ken Russell's film *Watch the Birdie*, made for BBC television's arts series 'Monitor' in 1962, featured David Hurn, a photographer who shared a house with Russell in Bayswater at the time. Russell's plot – intriguingly prescient of *Blow-Up* – cast Hurn as a fashion photographer who, as a redemptive from his lucrative but superficial existence, photographed an order of nuns tending incurable old men. In another sequence Hurn re-enacted the occasion when he had scaled a 4-metre high wall and outrun guard dogs to grab long-distance telephoto photographs of Princess Margaret with Captain Townsend – a pioneer paparazzo.

Ken Russell was himself a photographer in the 1950s. He studied at the South-West Essex School of Art, in Walthamstow, before being based as a freelance in London from 1954. Russell was a one-off, a transitional figure whose work anticipated elements of the new photojournalism, although his most original photographs involved elaborate, theatrical scenarios that presage his film direction. His photographs, which deserve to be much better

David Hurn 'Nucleus Coffee-Bar Basement' 1957.

known, were syndicated through Pictorial Press and he was a regular contributor to *Illustrated* magazine.

David Hurn began as a freelance on leaving the army in 1955. In 1956 his photographs of the Hungarian uprising (newsreel footage of which was also interposed in Russell's film) were published in both *Picture Post*, *Life*, and the *Observer*. But most of Hurn's photographs in the period up to 1960 were syndicated through two agencies, Pictorial Press and Reflex, and many were of aspirant young film actresses. He was soon in demand as a stills photographer on movies, and Charlton Heston, with whom he became friendly on the set of *El Cid*, offered Hurn the use of his New York apartment. Hurn used the opportunity afforded by this glamorous address to contact the Eileen Ford agency, offering to shoot model tests. He took these photographs to Alexander Liberman, art director of American *Vogue*, who was impressed enough to publish one of them. On the strength of this Hurn returned to London where he was immediately enlisted by Barry Trengove, art director of *Harper's Bazaar*, to photograph fashions in the reportage-influenced manner with which he had experimented in New York.

David Hurn Partisan Coffee House, Soho, London 1959.

David Hurn 'Margate Sea Front' 1963.

David Hurn 'Soho Strip Club, London' 1963.

118

David Hurn 'Margate Sea Front' 1963.

David Hurn 'British Theatre' *Queen* 1961.

(overleaf) **David Hurn** Partisan Coffee House, Soho, London 1959.

Hurn continued to photograph fashions for four years, for advertisers (including AquaScutum and Austin Reed) and *Harper's Bazaar*, in addition to features for other magazines, including *Queen* and *Town*, that occasionally coincided with his private projects. Hurn was, in a sense, swept into the media explosion, yet throughout this period of commercial success he consciously separated the financially rewarding activities from the photography that concerned him most. From the outset, Hurn had pursued themes of his own devising, usually in the evenings and at weekends. It was these alternative projects that Ken Russell had identified and adapted in his film; the photographs of the 'Sisters of Mercy' were actually a continuing preoccupation of Hurn's, as was his earlier documentation of London's coffee-bars. The coffee-bar series originated as a spare-time project when Hurn first moved to London; he worked as a shirt salesman in Harrods by day and photographed in the evenings and at weekends. Hurn and his friends regularly frequented the Soho coffee-bars, which enabled him to photograph relatively unobtrusively: 'We mostly hung around the Macabre, Bunji's, The Nucleus – which had the best jazz – and, slightly later, The Partisan Coffee House. Gary Winkler owned The Nucleus, which also had the best cheap pasta; I had a room in Gary's flat in Gloucester Place, a drummer, Danny Gray, also lived there, and a man who sold glass animals in Piccadilly Circus.'

Although he did little fashion photography after 1965, Hurn continued to work for magazines throughout the 1960s, and became a member of Magnum in 1967. He was particularly attracted to London night-life and some of his photographs – his documentation of a Soho strip club for example – were published in magazines. His series on beatnik London occupies a territory at the edges of different cultures – style and politics, fashion and documentary. Like Hurn himself perhaps, the photographs are poised between participation and detached observation. The lone student reading a book in the basement of the left-wing Partisan Coffee House is isolated – literally in a separate spatial plane – from the hubbub of music and conversation glimpsed in the back room. In another photograph, at street level, Hurn again emphasizes the division between interior and exterior, the animated expressions of those outside the plate glass window – looking in – diffused in a maze of reflections. Not all of the Meteors were disposed towards unequivocal involvement in the media explosion, and Hurn's reservations are compellingly expressed in the ambiguity of these images.

Bryn Campbell was another photojournalist who, throughout his career, has reserved as personal projects the kind of extended documentaries that would not be feasible in the commercial sphere. Beginning in 1957 he recorded over a period of three years a young but unsuccessful London artist, John Upton, and his wife, Rene, gaining a measure of access to their home and to their personal lives that can seldom be achieved within the confines of an

(above and below) **Bryn Campbell** 'John Upton' 1959.

urgent assignment. He continues to publish projects of this kind in book form. Campbell was unusual in that he was a writer, editor and picture editor as well as a photographer. He worked for three photography magazines – *Practical Photography*, *Cameras and Equipment*, and the *British Journal of Photography* before becoming picture editor of the *Observer* in 1964. His article 'Young Photographers of Great Britain' for the Swiss magazine *Camera* (June 1963) brought together the work of Terence Donovan, Philip Jones Griffiths, Campbell himself, David Hurn, John Bulmer, and Don McCullin. The text for this early conjunction of Young Meteors was written shortly after the advent of the first colour supplement, which Campbell saw as a mixed blessing; lamenting the dearth of photography books and exhibitions his realistic appraisal concluded that 'Creative photography in Britain revolves almost completely around our newspapers and magazines.'

Ian Berry emigrated to South Africa in 1952 and began as a photographer on the *Daily Mail* in Johannesburg, before working with Tom Hopkinson on *Drum*. He did not return to settle in Britain until late 1963, and thus was absent for most of the period covered by this study. He arrived, however, as the first among his generation of British photographers to have been elected a member of Magnum and, as the recipient of numerous awards for photojournalism, with a high reputation among the photography fraternity.

In the two years Berry had been based in Paris prior to his return he had built up a reputation for working in colour, especially for *Paris-Match*. He became the key photographer in the formulation of the second colour supplement to be launched in Britain, the *Observer Magazine*, and was responsible for the whole of its pilot issue in 1964. The stories he undertook for art director Romek Marber at the *Observer Magazine* were, however, photographed both in black and white and in colour. His documentation of South Africa under apartheid, and particularly his haunting photographs of the Sharpeville massacre, was doubtless a factor in assigning Berry projects such as 'The Blacks in Britain': the results display his remarkable facility in combining social documentation, psychological intensity, and lyrical realism. Berry continued as a photojournalist but also embarked on personal projects such as the survey of his native country, for which he received the first Arts Council photography bursary in 1974 and which was published in book form in 1978 as *The English*.

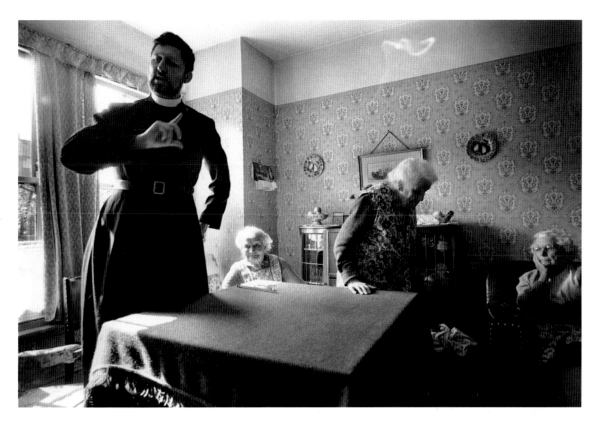

(above and below) **Ian Berry** 'A Mission's Failure' (Rev. Nick Stacey) *Observer Magazine* 1964.

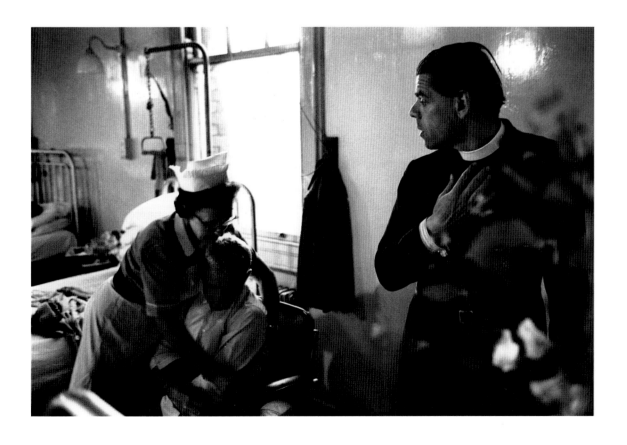

(overleaf) **Ian Berry** 'The Blacks In Britain' (nightclub, Cable Street, London)
Observer Magazine 1964 (unpublished).

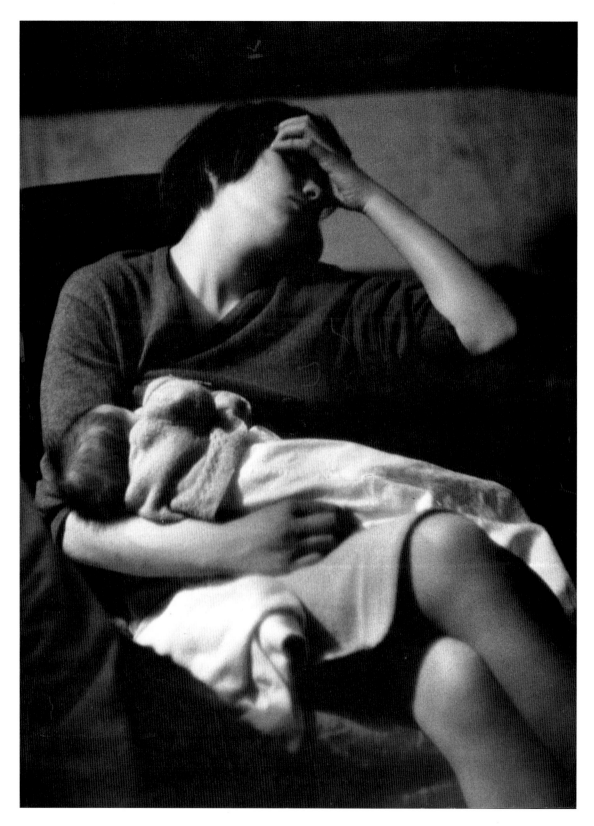

Bryn Campbell 'Rene Upton and Child' 1959.

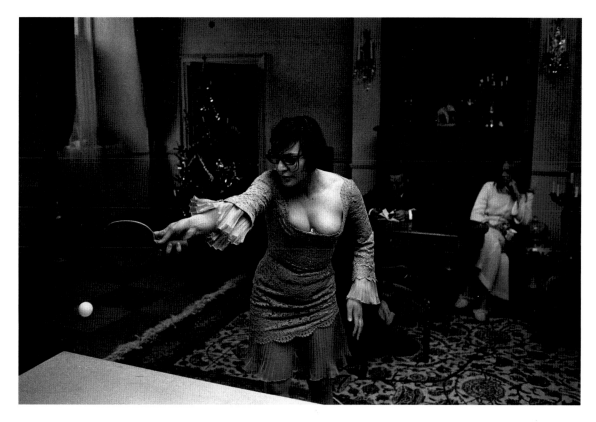

Graham Finlayson 'Off the set of Mai Zetterling's film *Night Games*' 1964.

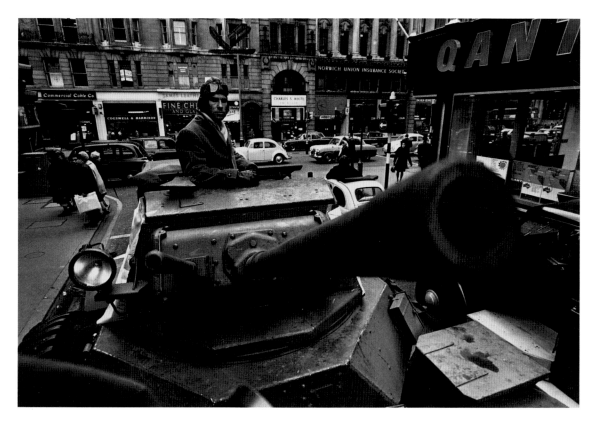

David Newell Smith 'Campaign against tourism in Greece' *Observer* 25 February 1965.

Philip Jones Griffiths Bryan Robertson (left), Director of Whitechapel Art Gallery *Town* 1966
(in front of Peter Phillips' painting AutoKUSTOMotive at the New Generation exhibition, 1964).

Robert Freeman IUA Congress July 1961
(Richard Hamilton's montage 'Glorious Techniculture' in front of Shell building, London).

Terence Donovan 'Spy Drama' *Town* October 1962.

Terence Donovan 'Strippers' *About Town* July 1961.

Terence Donovan 'Strippers' *About Town* July 1961 (unpublished).

A benign presence and exemplar, Bill Brandt continued to hover over British photography in the 1960s. A former photojournalist for Weekly Illustrated, Lilliput, *and* Picture Post, *Brandt had encompassed not only the public and documentary aspect of photography, but also the private and the pictorial, evinced in* Perspective of Nudes, *published in 1961. Gregg Toland's wide-angle cinematography in* Citizen Kane *influenced Brandt and the Meteors, whose looming perspectives were an automatic consequence of their use of wide-angle lenses: the deeply receding interior spaces of Terence Donovan's 'Strippers' photographs are Brandt homages, as is David Bailey's portrait of a social worker dwarfing a Brandtian Victorian terrace. Don McCullin's admiration for Brandt, evident in his high-contrast printing, is also conspicuous in his 'Street Boxing, North London, 1960', which recalls both the tension and hazy metropolitan atmospherics of Brandt's* Camera in London.

David Bailey Social worker *Town* December 1964 (unpublished).

Terence Donovan 'Strippers' *About Town* July 1961 (unpublished).

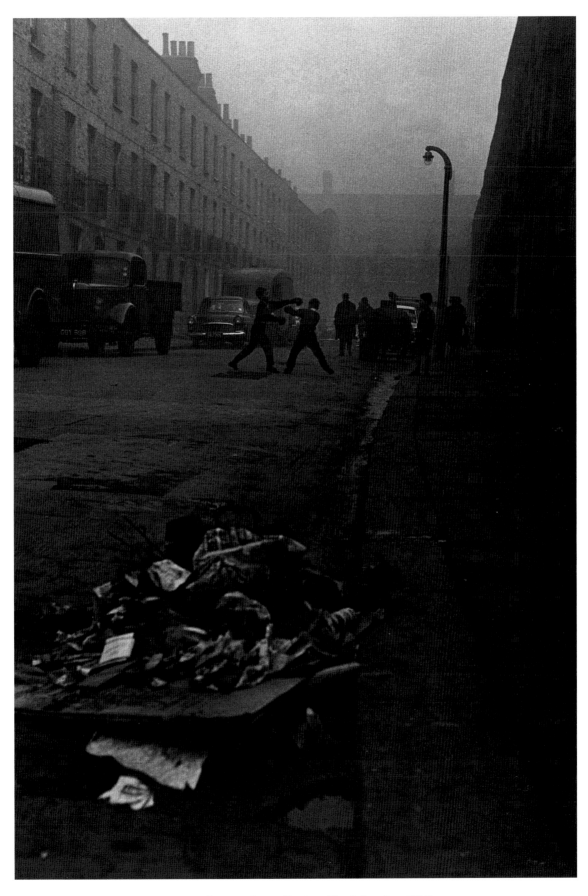

Don McCullin 'Street Boxing, North London, 1960'.

Terence Donovan Celia Hammond 15 December 1961.

Certain models have assumed the role of a fashion photographer's muse, the inspiration for a major shift in style. When Terence Donovan first photographed Celia Hammond in 1961 she at once became his favourite model. The two photographs here were not commissioned by a magazine and were not intended for publication; rather they reveal Donovan's continuing experimentation with lighting techniques and with gesture, the photographer's equivalent of an artist's sketchbook.

Sue Murray was similarly David Bailey's principal model from 1964. Overleaf she is depicted in a casual snapshot taken in Bailey's studio on the occasion of their first meeting, and in a Vogue *photograph typical of Bailey's environment-less graphically economical style of the mid-1960s. The successful fashion photographer responds to the contemporary language of pose and gesture, but here Donovan and Bailey extend the dialogue, pushing their own recoding of the body.*

Terence Donovan Celia Hammond 22 January 1963.

David Bailey Sue Murray 14 September 1964.

David Bailey *Vogue* 15 September 1965 (Sue Murray).

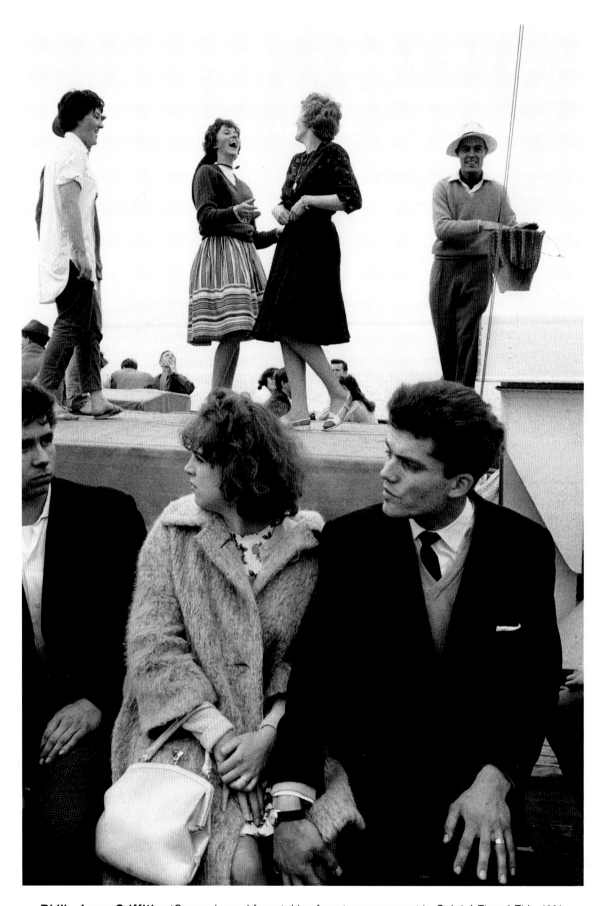

Philip Jones Griffiths 'Cross-channel ferry taking fans to pop concert in Calais' *Time & Tide* 1961.

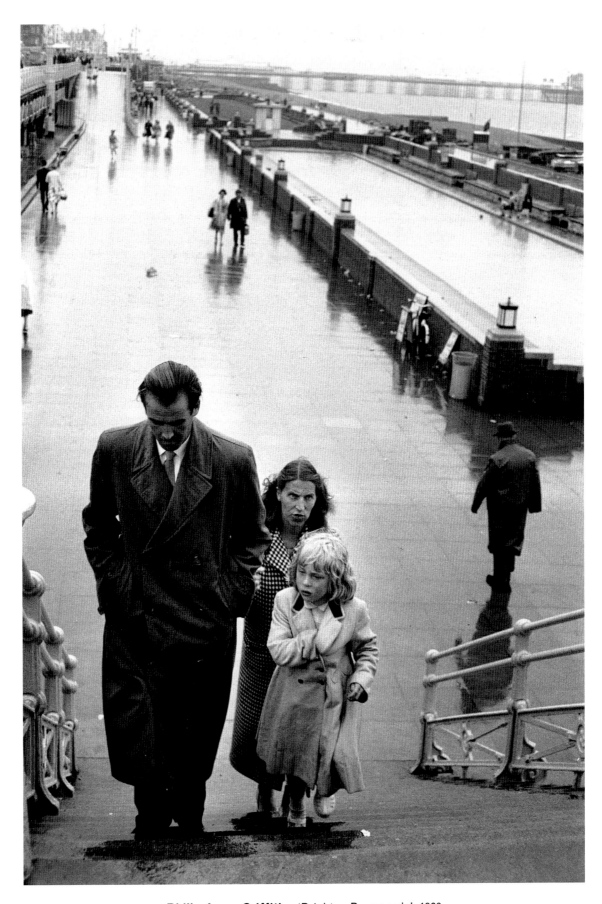

Philip Jones Griffiths 'Brighton Promenade' 1960.

The editors and art directors of British periodicals did not, of course, restrict themselves to using British photographers. At *Queen*, for example, Jocelyn Stevens and Mark Boxer assigned major features to Brian Brake, Marc Riboud and Bruce Davidson, in addition to Henri Cartier-Bresson. Tom Wolsey frequently commissioned William Klein – at *Town*, *Queen*, and for fashion advertising – and Robert Freson and Eve Arnold were regular contributors to the *Sunday Times Colour Magazine*. Eve Arnold, a particularly important figure at the magazine, was unusual in the context of British photojournalism not only for being an American but also for being a woman.

It is difficult to account for the dearth of female photojournalists, with the single exception of Jane Bown, in this period. Jay Juda and Nancy Sandys-Walker were established in Britain as fashion photographers in the 1950s, and were joined a little later by Sandra Lousada. Tessa Grimshaw was under contract to the *Observer* in 1960 and subsequently worked regularly for the *Tatler*: the majority of her photographs were, however, still-lifes for which, under her married name of Tessa Traeger, she has since become justly acclaimed. In 1963 she shared a London studio with Penny Tweedie, like Traeger an alumnus of B. Ifor Thomas's influential Creative Photography course at Guildford School of Art. Penny Tweedie began in 1961 at the studios of *Queen* and its companion travel monthly, *Go!*, as a darkroom assistant, then as a photographer; as a freelance her ambition to be a photojournalist was frustrated, since 'the only people who would give me work were the bloody women's magazines'. Eventually, her photographs for the initial campaign of *Shelter* were instrumental in establishing both this important charity for the homeless, and Tweedie herself as a photojournalist, as her 'Gorbals, Glasgow, 1966' powerfully demonstrates.

One of the most important and prolific photographers for the *Sunday Times Colour Magazine* was Lord Snowdon. His photographs of British artists regularly distinguished its pages and in turn provided much of the source material for a book on the subject, *Private View*, published in 1965. Large-format, superbly printed, and skilfully designed by Germano Facetti, it was one of the most striking and informative photography books of the decade. In the same year David Bailey's *Box of Pin-ups* was published, the deification of a new Pop, socially mixed, meritocracy. The desire among the Meteors to present their photographs in book form – that is, outside the

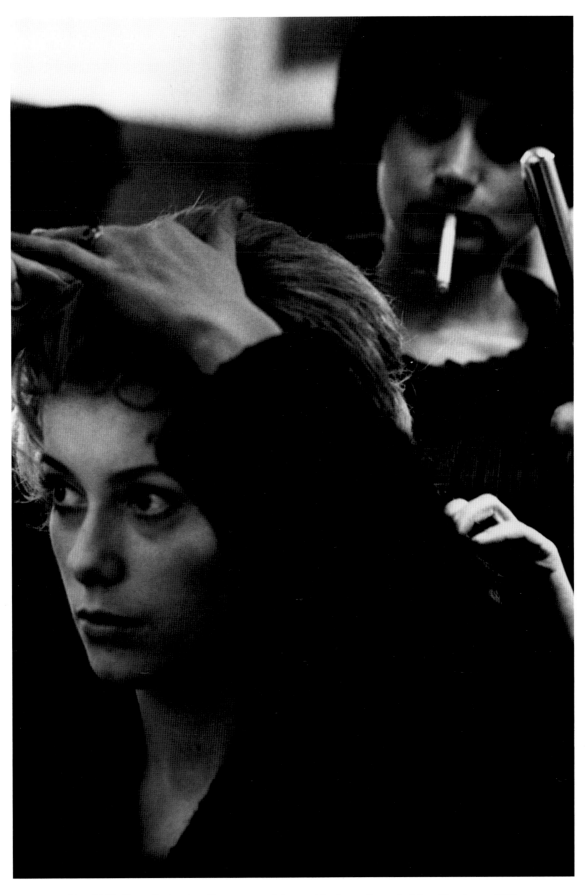

David Bailey Catherine Deneuve and Agnes Varda on the set of *Les Creatures* 1965.

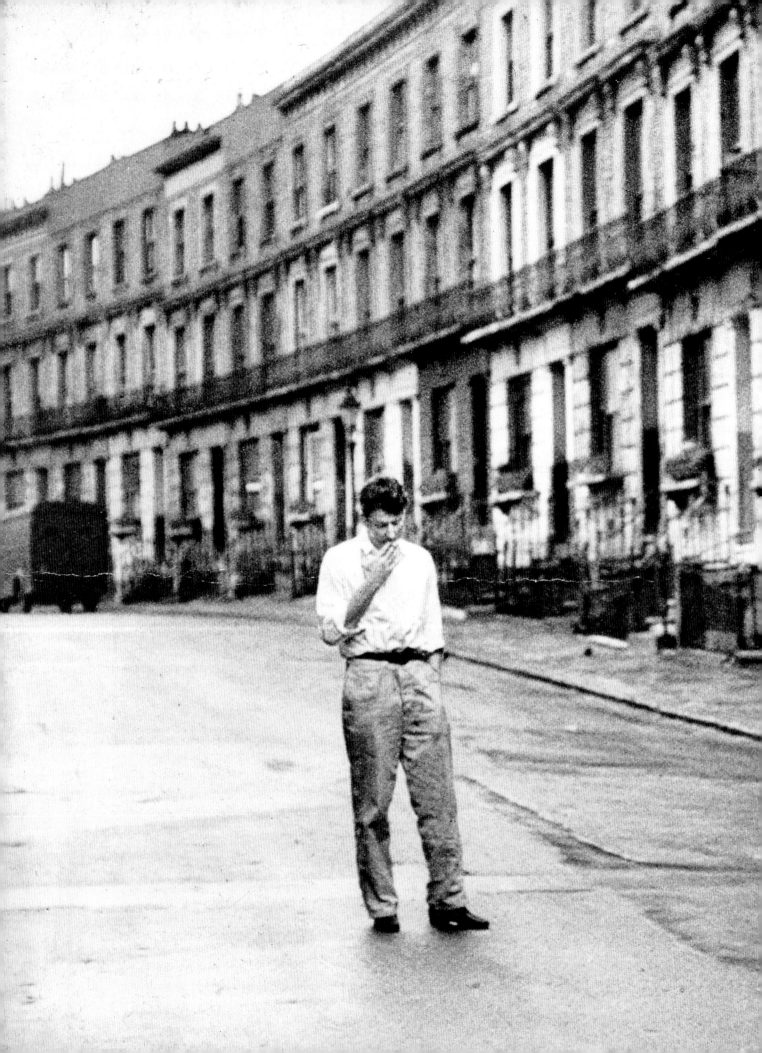

context of magazines – portended one of the most significant changes in photography.

The year 1965 marked a watershed in British history that was reflected in magazine culture. Doubts that Harold Wilson's Labour government would deliver on its promise of progress through modernizing technology were attended by a collapse of confidence in the linear trajectory of modernist ideals in general. The design of the most significant new magazine, *Nova*, launched in 1965, was strongly influenced by the modernist super-graphics of *Twen*, but its content acknowledged the imminence of social upheaval and caught the spirit of eclecticism and the historical style revivals that typified the remainder of the decade.

The colour supplements, for their part, were faced with the challenge of colour television (the first colour broadcasts were in 1966), and in order to continue to attract advertising were obliged to reorientate their editorial policies. The implications for photojournalists were soon clear. John Bulmer dates his own disillusion to 1969, when the extensive coverage he brought back to the *Sunday Times Colour Magazine* of the crisis in North Korea was drastically commuted: 'I had gone with the writer Philip Oakes and my pictures reflected our concern with the plight of the North Koreans; coming from a democracy it was difficult to imagine the horrific conditions under which they were living: but what they ran was two pages of close-up photographs of signs, twisting it into a kind of pop art feature.' The reductive editing and depoliticizing of his images hastened Bulmer's withdrawal from photojournalism. Four years later he arranged a meeting with Hunter Davies, recently installed as editor of the magazine: 'I was one of the first photographers to get a visa to work in Burma since the war, but this raised absolutely no interest; instead I was told that in future the editorial policy had to be geared to three things: crime, fashions, and middle-class living'. 'Today,' he says, 'the received notion of the *Sunday Times Magazine* in the 1960s is that it was all Christine Keeler, The Beatles, and Carnaby Street, but if you look at its contents it also incorporated quite serious features about many substantive issues.' Eventually, BBC television financed his Burma project and since 1973 Bulmer's career has been largely devoted to documentary film-making.

Certain reforms in British photography in the 1960s were instigated in response to a more international perspective on photography and its history, and particularly the theoretically healthier state of the medium in the USA. The transformation of a British magazine provided the reformers with their mouthpiece. *Camera Owner*, founded in 1964 and aimed at the photo-novice, was already in financial jeopardy by the following year, when Bill Jay became editor. Colin Osman, 'a singular benefactor', came to its rescue and together he and Jay shifted its content 'away from snapshot appeal towards serious photography'. Confirming its new

Philip Jones Griffiths 'The Fashion Editors' (Georgina Howell at the *Observer*) *Nova* January 1966.

Raymond Moore Pembrokeshire 1965.

direction, the title of their magazine was changed to *Creative Camera Owner* in 1967 and its symbolic aestheticization completed in the following year when it became simply *Creative Camera*. Jay, who edited the magazine until 1969, was also responsible for another notable venture, *Album*, of which twelve issues appeared in 1970 and 1971. To set the significance of *Creative Camera* into perspective it must be remembered that during this period few photography books were published, there were no photography galleries, no workshops, and no Arts Council grants to photographers – a situation that would rapidly change. The magazine continued to provide a showcase for working photojournalists, a field with which Jay was familiar (in 1968 and 1969 he was simultaneously picture editor of the *Weekend Telegraph*), but with the momentum of what became identified as the 'photography revival', it underwent a radical change of emphasis.

By 1965 a line of British photographers was emerging, beginning with Raymond Moore and Tony Ray-Jones, that rejected the validity of photography associated with the mass media. Moore trained as a painter at the Royal College of Art and took up photography seriously in 1956. Since he eschewed the commercial sphere, his photographs remained virtually unknown until

Tony Ray-Jones Southport 1968.

his Welsh Arts Council exhibition in 1968 and publication in *Creative Camera* in November of that year. Moore has been compared to Minor White and Lee Friedlander. Photographs such as his 'Pembrokeshire, 1965' align with the Minor White axis: solemn, bleak, but intensely serious, they helped inaugurate a new school of landscape photography in Britain.

What was soon to become the prevailing imperative was adumbrated by Tony Ray-Jones in *Creative Camera* (October 1968): 'I feel,' he commented on photography, 'that it is perhaps a great pity that more people don't consider it a medium of self-expression instead of selling themselves to the world of journalism and advertising.' Ray-Jones was a fine photographer, about whom numerous myths have sedimented. It is a misconception, for example, to suggest that he strove to take photographs for which he would not receive payment, and neither did he pioneer a new kind of photographic vision – in Britain alone the groundwork laid by Ian Berry, Philip Jones Griffiths, and David Hurn refutes this. He did, however, help to shift the context of photography from the magazine page to the gallery wall, a campaign that gained sufficient support that within eight years Bryn Campbell could convincingly claim a 'great British photographic revival' (*The Times*, 5 November 1976). Campbell outlined the evidence for the

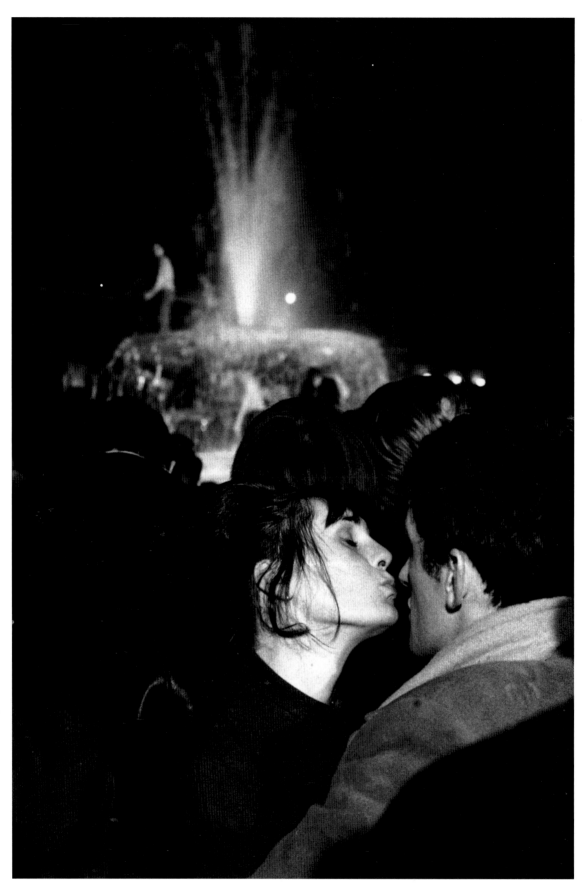

Ian Berry 'New Year's Eve, Trafalgar Square, London' 1964
(not an assignment, but published several times, including in *The English* 1978).

remarkable growth in the number of photo-galleries, both in London and the provinces, the availability of grants and bursaries, and institutional recognition of the medium at the National Portrait Gallery and the Victoria & Albert Museum. In the *U.S. Camera Annual, 1977,* William Messer's extended survey, 'The British Obsession: About to Pay Off ?' provided an American perspective, and concluded that British photographers had not only partly reversed the USA's former hegemony, they were 'holding keys to the medium's secret chambers in the future'.

Among the talented successors of Raymond Moore and Tony Ray-Jones were Homer Sykes, Chris Killip, Chris Steele-Perkins, Martin Parr, and, more recently, Nick Waplington and Richard Billingham, all of whose work could be termed 'photojournalistic'. The documentary mode continues as a force in photography, but the revival of large-circulation applied photojournalism, combining the aesthetic and functional elements of the Meteors, is unlikely. The decline of photojournalism was ultimately caused by factors external to photographic debate: for example, the primacy and rapidity of globalized television as a news-casting medium, and the consequent changes in the printed media, have resulted in a contraction of in-depth news reporting that generally precludes the extended photo-essay. In terms of photographic history, however, it remains a paradox that while photographers and critics debated the medium's status as an art, the cultural significance of photojournalism that reached an audience of thousands, even millions, was neglected.

After 1965 many of the Meteors achieved eminence in photography, and some of the photojournalists – notably Ian Berry and Philip Jones Griffiths, both of Magnum – remain active as photo-reporters of international affairs. Others, such as David Bailey and Terence Donovan, more than consolidated their reputations, although they largely confined their published photography to modes that could not be described as journalistic. The emergence of the Young Meteors coincided with a massive social transformation. Roger Mayne's photographs celebrated the rapturous emancipation from bodily inhibition and grey austerity: a new agenda had been set, and the legacy of the youthful energy that flowed from the Meteors in this exhilarating period is a document of profound cultural change.

(overleaf pp154-155) **Penny Tweedie** 'Gorbals, Glasgow' (for *Shelter*) 1966.

(overleaf pp156-157) **Philip Jones Griffiths** 'Dead Vietcong, Vietnam 1967'.

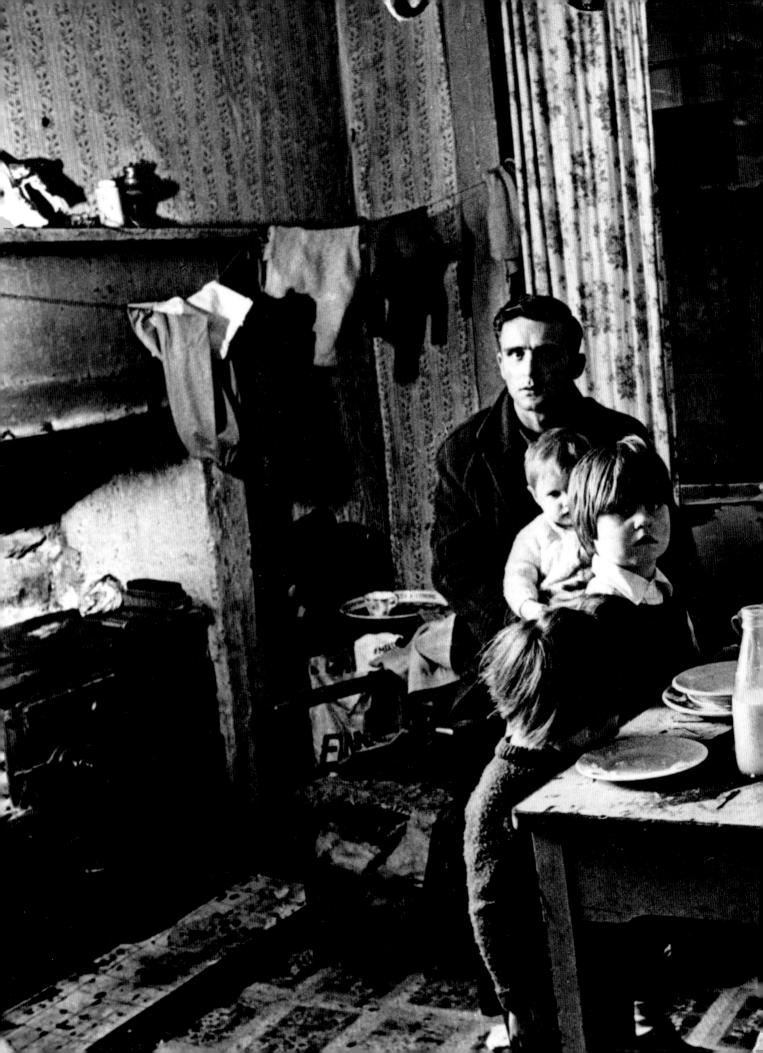

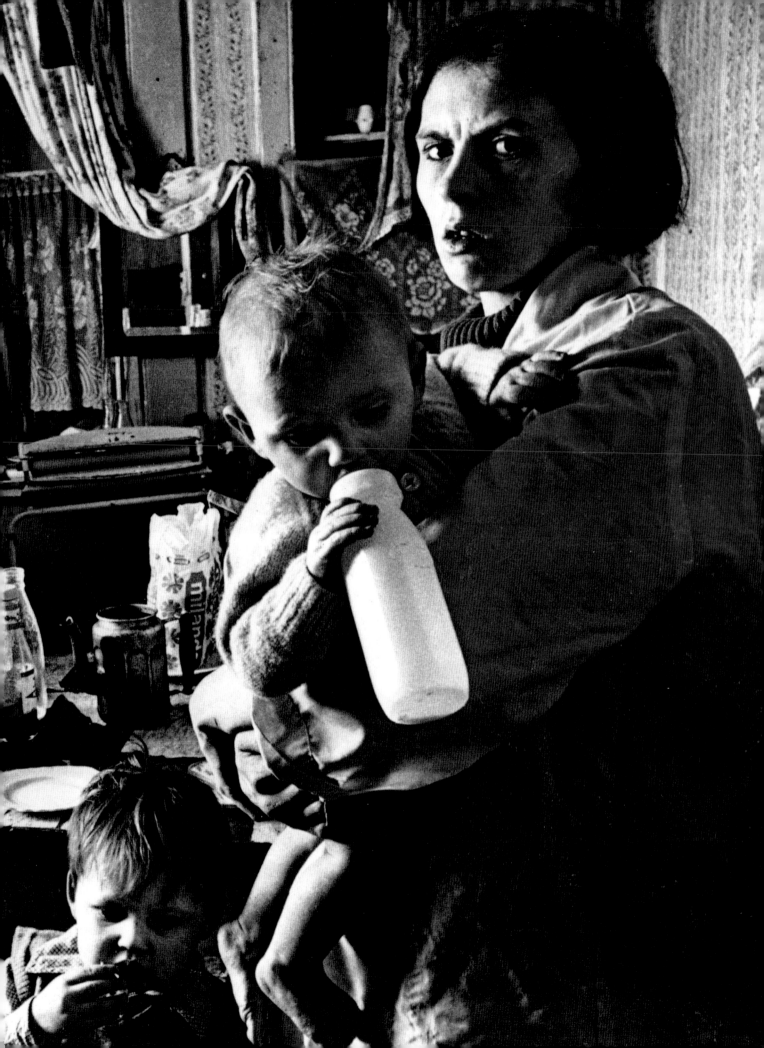

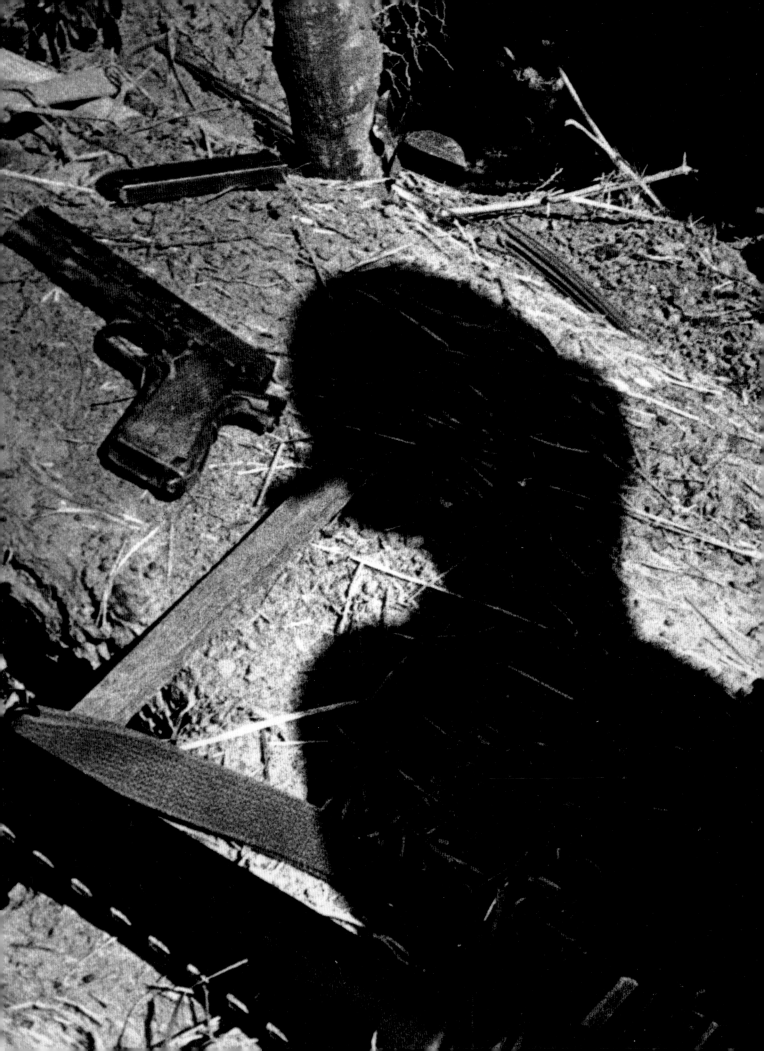

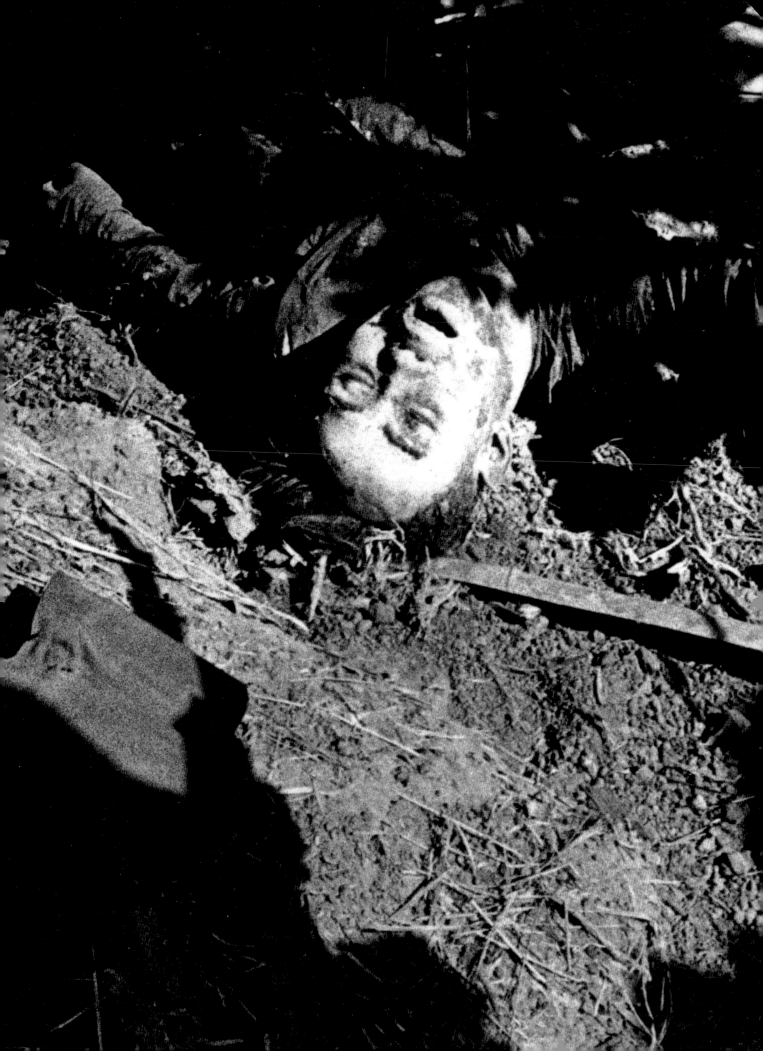

My sincere thanks are due firstly to all of the photographers who have so kindly co-operated in this project, for their conversation, for so readily making their work available, and for the pleasure of their company.

I also wish to express my gratitude to Maggie Angeloglou; Ernest Baker; Terry Boxall; Tanya Braganti; Zelda Cheatle; Sara Cubitt; Sue Davies; Ian Dickens; Diana Donovan; Ken Garland; Philippe Garner; Janet Goodwin; Mark Haworth-Booth; Janet Henderson; Paul Hill; Ann Jellicoe; Lisa Hodgkins; Alex Kroll; Maria Kroll; Richard Lannoy; Robert E. Lassam; Barbara Laurie; Henry Lewis; Hildegard Mahoney; Jan Mancini; Tony Mancini; Lynda Morris; Robin Muir; Chris Mullen; Colin Osman; Grace Osman; Michael Rand; Toni del Renzio; Alan Smith; Paul Smith; Barry Taylor; Roger Taylor; Tessa Traeger; Greg Whitmore; Tom Wolsey.

Special thanks are due to my collaborators at the National Museum of Photography Film and Television: Amanda Nevill; Gregg Hobson; Janis Britland; Alison Jarman.

Alex Seago, author of *Burning the Box of Beautiful Things* (Oxford, 1995), the definitive study of graphic design in the 1950s and 1960s, was extremely helpful. Other important contextual sources consulted include Mark Haworth-Booth: *The Street Photographs of Roger Mayne* (Victoria & Albert Museum, 1986); David Mellor: *The Sixties Art Scene in London* (Barbican Art Gallery, 1993) and Anna Massey: *The Independent Group* (Manchester, 1995).

Bryn Campbell was a witness to many of the events described in this book and has most generously and graciously shared with me his first-hand knowledge of photography in the period.

Finally, I was especially fortunate to be able to call on the help of three members of my family, my wife Amanda Harrison and my children Ben and Francesca Harrison.

All photographs are reproduced courtesy the photographer except the following:

Courtesy Condé Nast Publications: pp. 31, 38, 39, 76, 77, 98.

Courtesy Science and Society Picture Library: p.151

Courtesy the *Observer*: pp.10, 11, 64, 72 (upper), 74, 129 (lower).

Courtesy Topham Picture Point: p.114.

Private Collection, London: pp.138, 139, 150.

Janet Henderson: pp. 20, 21, 24, 25, 26, 27, 29.

Published by Jonathan Cape 1998

1 3 5 7 9 10 8 6 4 2

First published in Great Britain in 1998 by
Jonathan Cape
Random House, 20 Vauxhall Bridge Road, London SW1V 2SA

Random House UK Limited Reg. No 954009

A CIP catalogue record for this book is available from the British Library

ISBN 0-224-05129-6

Editor: Mark Holborn
Design: Martin Harrison
Macintosh Operator: Ben Harrison

Printed in Italy by Amilcare Pizzi, Milan